the
DAILY FACE

the

DAILY FACE

25 MAKEUP LOOKS
for **DAY, NIGHT,** *and* **EVERYTHING IN BETWEEN!**

Annamarie Tendler
PHOTOGRAPHS BY *Justin Ouellette*

CHRONICLE BOOKS
SAN FRANCISCO

Library of Congress Cataloging-in-Publication Data:
Tendler, Annamarie.
 The daily face / Annamarie Tendler ;
photographs by Justin Ouellette.
 pages cm
ISBN: 978-1-4521-2810-8
1. Beauty, Personal. 2. Face—Care and hygiene. 3. Cosmetics. 4. Women—Health and
hygiene. I. Title.

RA778.T42 2014
646.7'2—dc23

 2013040446

Manufactured in China

Designed by Hillary Caudle

Benefit Creaseless Cream Shadow, Instant Brow Pencil, and SunBeam are registered trademarks of Benefit
Cosmetics, LLC. The Body Shop is a registered trademark of The Body Shop Intl. plc. ChapStick is a
registered trademark of Wyeth LLC. Cinema Secrets is a registered trademark of Cinema Secrets, Inc. Duo
is a registered trademark of American Intl. Industries. Instagram is a registered trademark of Instagram,
LLC. Investigation Discovery is a registered trademark of Discovery Communications, LLC. Josie Maran
is a registered trademark of Josie Maran Cosmetics, LLC. L'Oréal Carbon Black Voluminous Mascara and
True Match Concealer are registered trademarks of The L'Oréal Group. Laura Mercier Second Skin Cheek
Color is a registered trademark of Gurwitch Products, LLC. MAC Cream Colour Base, Fluidline, LipGlass,
and Lipmix are registered trademarks of Estee Lauder Cosmetics Ltd. Make Up For Ever Aqua Cream, Aqua
Eyes, Aqua Liner, and HD Concealer are registered trademarks of Make Up For Ever. Q-tip is a registered
trademark of Unilever Supply Chain, Inc., Conopco, Inc. Sephora is a registered trademark of Sephora Corp.
Tarte Cheek Stain, LipSurgence, and Skinny SmolderEYES are registered trademarks of Tarte, Inc. Tom
Ford is a registered trademark of Thomas C. Ford.

10 9 8 7 6 5 4 3 2 1

Chronicle Books LLC
680 Second Street
San Francisco, California 94107
www.chroniclebooks.com

To my mom, Marlene, for being my biggest fan.
And also for letting me wear lipstick to the mall
when I was five.

CONTENTS

8 INTRODUCTION

11 MAKEUP BASICS

Face Chart	12
Essential Brushes	14
Eyes	17
Skin	32
Lips	36

39 DAYTIME LOOKS

The Afternoon Date	40
Pretty in Pink	44
The Vacation	48
Emerald City	52
Sugar Plum	56
Gold Day	60
Summer in the City	64

69 EVENING LOOKS

Marilyn	70
Smoke Alarm	74
Little Odessa	80
The Dinner Party	84
Grape Juice	88
Brooklyn Nights	92
Moss	96
Pink Diamonds	100

105 PARTY LOOKS

Welcome to Miami	106
Red Light	110
The Starlet	114
Twiggy	118
Purple Haze	122
Golden Eye	126
After Midnight	130

137 COSTUME LOOKS

Snow Leopard	138
Peacock	142
Cracked China Doll	146

Introduction

Hello and welcome to *The Daily Face*. This book was born from the blog I started back in 2010, when I noticed a lack of easy-to-use makeup resources. I created this book especially for *you*, the modern, do-it-yourself girl; the woman who wants to look amazing, but is too busy taking over the world to spend an hour getting ready.

So what's my secret to getting fabulous makeup in a reasonable amount of time? Good question! It's my minimalistic, no-fuss approach, which rejects the notion that we need to cover our faces in a full makeup mask in order to look good. Trust me; you don't need it.

As a makeup artist, I've watched the old-school "foundation-concealer-powder" trifecta fall by the wayside for everyday makeup, and I couldn't be happier. I am a firm believer in only using foundation for special events, like your wedding, or when you know you're going to be photographed. Even then it should be used sparingly. I believe makeup is about hitting the right spots with the right amount of makeup, not painting the entire face. Allow your skin to breathe, and you're sure to notice a difference in its overall radiance and beauty! None of these looks are dependent on foundation or concealer. If you want to wear a tinted moisturizer or concealer, go right ahead; if not—don't worry about it!

OK, so here's how the book works. Going forward you'll find 25 looks, which fall into four categories: Daytime, Evening, Party, and Costume. You'll be able to create everything from an Afternoon Date look to a sultry After Midnight smoky eye and a classic Starlet. Each look has simple step-by-step instructions, as well as how-to photos, which make everything easier. I outline the types of products and colors you'll need and also include specific recommendations just in case you want to use the same exact products for the look. You don't need to go out

and buy these, though. Feel free to work with the brands and products you like! Should any of the products mentioned in this book go off the market, I keep a running list of alternatives on my website, thedailyfacemakeup.com.

As you work through the book, you'll probably notice that I use a lot of the same products over and over. In keeping with my philosophy of simplicity, I feel it's important to be able to do a lot with a little. It will save you a ton of money over the course of your long makeup-wearing years. Hopefully this book will get you into the habit of using your favorite products in lots of different ways.

Now it's time for you to jump in to *The Daily Face*! I recommend going through the basics chapter first; it includes helpful application instructions and tips that will help you immensely when re-creating the looks. You are about to take on the world (and look at yourself in the mirror a lot) with an arsenal of looks that can take you from the office to a date to the craziest party you've ever been to.

C'mon, turn the page already!

— Anna

EYELASHES Black mascara, false bottom
strip lashes
*Shown: L'Oréal Carbon Black Voluminous
Mascara, Make Up For Ever Nude Lashes 051*

CHEEKS Soft pink cream blush
*Shown: MAC Cremeblend Blush in
Ladyblush*

LIPS Brick red lipstick, clear high-shine gloss
*Shown: Tom Ford Lip Color in Crimson
Noir, MAC LipGlass in Clear*

BRUSHES/TOOLS

Sponge applicator

Powder brush

Tapered blending brush

Small tapered brush

Small angled brush

Lash glue

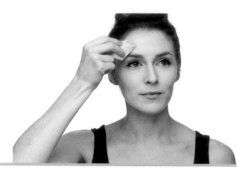

Choose a foundation much lighter than your skin tone, mix it with opaque white face paint, and, using a sponge applicator, apply a thin layer to your face and neck. Be sure to cover the outer corners of **STEP ONE** the lips as well.

You don't want this to look like clown makeup—you want it to appear as though it is your natural skin. To achieve this effect, keep your application of white very light and be sure to cover the face evenly, especially in hard-to-reach places like around the eyes and the hairline.

TIP

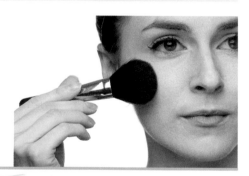

Apply a light dusting of powder over the entire face with a **STEP TWO** powder brush.

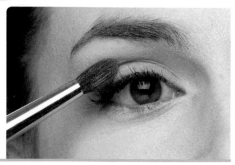

With a tapered blending brush, apply beige eye shadow to the entire lid, from lash line **STEP THREE** to brow bone.

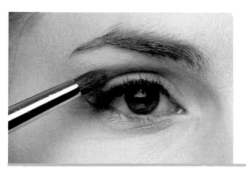

Using a small tapered brush, apply slate eye shadow to the eye socket bone. Remember, the eye socket bone is just above the crease, so the shadow is visible when your eyes are open.

STEP FOUR

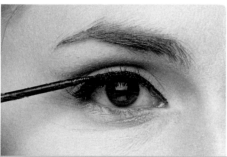

Apply a thin line of black liquid liner from the inner to outer corners of the eyes. Do not wing this liner. (This is one of the only times I'll give that direction, but seriously, have you ever seen a doll with winged liner?)

STEP FIVE

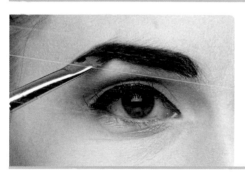

Using a small angled brush, apply black gel liner to the eyebrows, making them into a clean, defined shape.

STEP SIX

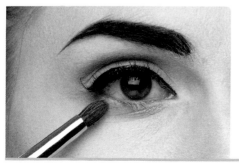

With the small tapered brush, apply deep plum eye shadow very lightly to the outer edges of the lower lashes.

STEP SEVEN

CONTINUED

STEP EIGHT Apply soft pink cream blush to the apples of the cheeks with your finger.

On a china doll, the blush is actually lower on the cheeks than blush would normally be placed. Note my placement. If you need further inspiration, this might be a perfect time to use your good friend Google image search.

TIP

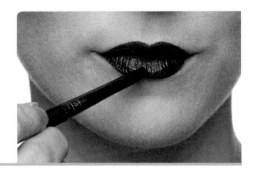

STEP NINE Apply brick red lipstick. Take the lipstick slightly beyond your natural lip on the top and bottom and don't take the lipstick all the way to the outer corners of the lips. This will give the illusion of a small mouth, typical on china dolls.

Use a lip liner to clean up your edges. You can also take the sponge applicator you used to apply your face paint and further white out the part of your lips that doesn't have lipstick on it.

TIP

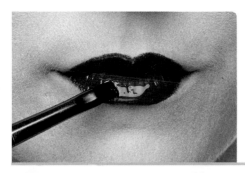

Apply clear high-shine gloss to
the lips.

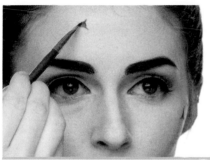

Using a small angled brush,
apply dark brown eye shadow
to the forehead and top of the
cheekbone where your cracks
will go. I suggest starting with
a triangle shape and extending
the cracks from there.

*Here's my reasoning behind the crack placement: delicate items wear first
at their highest points. On a doll's face, those would be the forehead and
cheekbone—these areas would come into contact with the ground or a
wall first.*

TIP

CONTINUED

Once your brown areas are in place, fill part of them in with black gel liner, making sure to fade the black into the brown so there are no hard lines. You are creating dimension here. Next, extend the black gel liner delicately away from the points of the triangle, creating spider cracks radiating from the larger middle crack. Take your creativity into your own hands—you can make these spider cracks as long or short as you wish.

STEP TWELVE

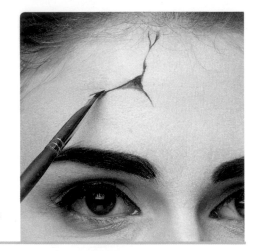

Apply mascara and affix delicate strip lashes (see page 30) to the bottom lashes. I cut the strip lashes in half so they only extend from the outer corner to about mid-eye.

STEP THIRTEEN

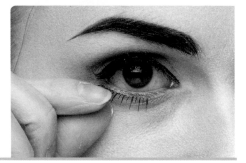

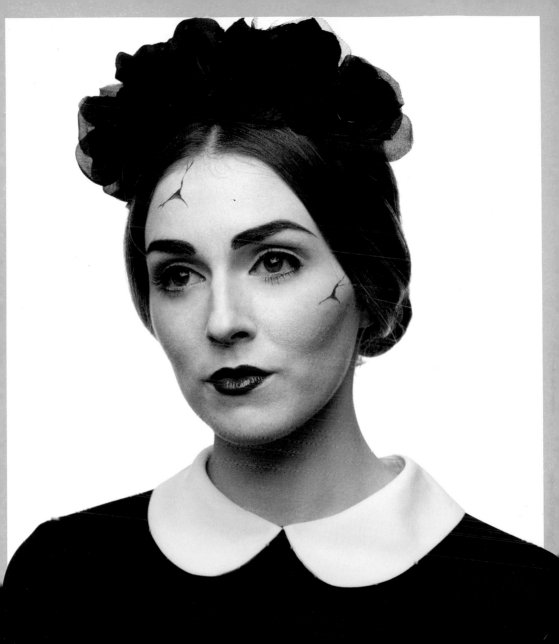

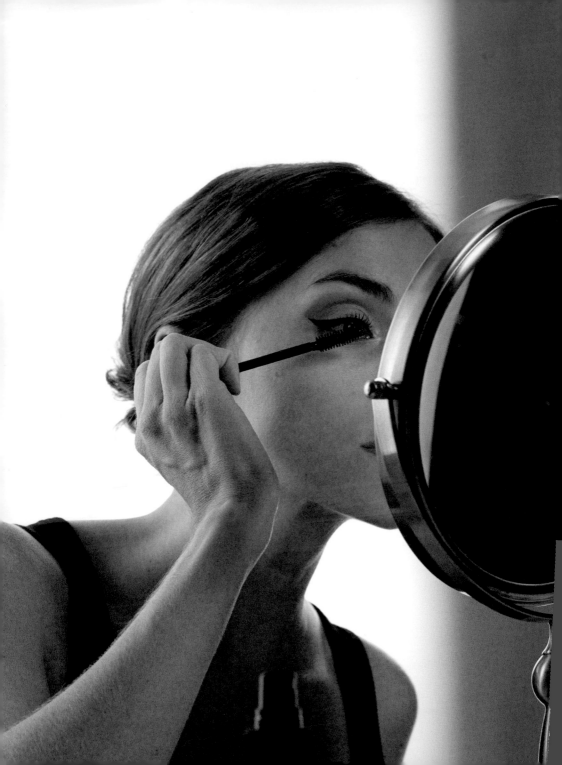

A Final Thought on Makeup

I love makeup. I think that is pretty obvious. That said, I think it should be used sparingly. Not only because no one looks good with makeup caked all over her face, but because of my own concerns with the safety of ingredients in cosmetic products. There is a ton of conflicting information about what ingredients are "safe" and "not safe," but it's difficult to get all the facts. As a consumer and user, I try to educate myself about cosmetic ingredients so I can decide for myself what I'm willing and not willing to put on my face.

Unfortunately, completely green, high-quality, long-wearing makeup doesn't exist (yet). That said, there are certainly companies dedicated to creating makeup without many of the questionable ingredients such as parabens and sulfates. If you are interested in learning more about the ingredients in your makeup, Environmental Working Group (www.ewg.org) is a great resource.

My mom raised me to have a more holistic approach toward life, but I also love makeup, which makes my beliefs and my desires somewhat conflicting. Here's my general philosophy: Like most things, makeup is great, but in moderation. This has informed my whole approach as a makeup artist and makeup wearer. I am never going to stop wearing makeup—it's just too much fun—but I *am* going to make informed decisions about what products I choose, how much I wear, and how regularly I wear it. I urge you to do the same!

Inspiration

Glamour

www.glamour.com

A great resource for all things fashion, makeup, and hair.

Nylon

www.nylonmag.com

A place to get the low-down on new products people love as well as find fashion and beauty inspiration.

BLOGS

AM – The Daily Face

annamarie.tumblr.com

The original Daily Face! On my blog you can see all the looks I've created over the past two years, including dozens that are not in this book.

The Beauty Department

www.thebeautydepartment.com

A site for fun makeup and hair tutorials. You'll find everything from product recommendations to glamorous ponytails and creative braid styles.

Rookiemag.com

www.rookiemag.com

Rookie is filled with amazing craft tutorials, photos, and articles perfect for your own inspiration. You can even find a few makeup tutorials.

BOOKS

The Art of Makeup by Kevin Aucoin

The quintessential makeup book, owned by most every young girl. If you don't have it, buy it!

Making Faces by Kevin Aucoin

Kevin Aucoin showcases the true transformative abilities of makeup by making up celebrities to look like famous characters.

Do-It-Yourself Monster Makeup Handbook by Dick Smith

The original monster makeup book. Perfect for creating beautiful zombies, monsters, and other costume makeup looks.

Acknowledgments

I would like to thank the following people:

Tumblr for creating an incredible online community where people can be creative and exchange ideas. It represents all the best parts of the Internet. Adriann Ranta, my literary agent, for giving me the opportunity and guidance to turn The Daily Face into a book. Chronicle Books, especially my editor Laura Lee Mattingly, for actually letting me make this book and for dealing with my poor punctuation skills. My family, for all their love and support. My amazing photographer and friend, Justin Ouellette. The stylists, Jill Bream, Carmel LoBello, and Allison Pearce. Irene Marquette, my reader. The models, Marina Cockenberg, Amanda Ferri, Nasim Pedrad, Sara Sawyer, Rachel Specter, Amanda Walsh, and Petunia the Frenchie. Rachel Antonoff, Nasty Gal, for providing wardrobe pieces. MAC Cosmetics, NARS, Make Up For Ever, Smashbox, Laura Mercier, and Benefit for their generous makeup contributions.

Most of all, my husband, John, for his endless support, love, and humor. If it weren't for you, *The Daily Face* would just be something of my imagination. I love you forever.

Index

A

After Midnight, 130–35
The Afternoon Date, 40–43

B

blush, 34–35
Brooklyn Nights, 92–95
brows, 31
brushes, 14–16

C

cheek stains, 35
Cleopatra method, 23
concealer, 33–34
costume looks
 Cracked China Doll, 146–53
 Peacock, 142–45
 Snow Leopard, 138–41
Cracked China Doll, 146–53

D

daytime looks
 The Afternoon Date, 40–43
 Emerald City, 52–55
 Gold Day, 60–63
 Pretty in Pink, 44–47
 Sugar Plum, 56–59
 Summer in the City, 64–67
 The Vacation, 48–51
The Dinner Party, 84–87

E

Emerald City, 52–55
evening looks
 Brooklyn Nights, 92–95
 The Dinner Party, 84–87
 Grape Juice, 88–91
 Little Odessa, 80–83
 Marilyn, 70–73
 Moss, 96–99
 Pink Diamonds, 100–103
 Smoke Alarm, 74–79
eyebrows, 31
eyeliner, 17–23
eye shadow, 24
eye socket bone, 13

F

face chart, 12–13
false lashes, 28–30

G

gloss, 36, 37
Gold Day, 60–63
Golden Eye, 126–29
Grape Juice, 88–91

H

highlighter, 35

L

lashes, 25–30
liner, 17–23
lip gloss, 36, 37
lip pencil, 36, 37
lipstick, 36, 37
Little Odessa, 80–83

M

makeup. *See also individual products and looks*
 for eyes, 17–31
 for lips, 36–37
 safety and, 155
 for skin, 32–35
 tools for, 14–16
Marilyn, 70–73
mascara, 25–26
moisturizer, 33
Moss, 96–99

N

Natural Liner method, 21

P

party looks
 After Midnight, 130–35
 Golden Eye, 126–29
 Purple Haze, 122–25
 Red Light, 110–13
 The Starlet, 114–17
 Twiggy, 118–21
 Welcome to Miami, 106–9
Peacock, 142–45
Pink Diamonds, 100–103
Pretty in Pink, 44–47
Purple Haze, 122–25

R

Red Light, 110–13

S

safety, 155
'60s Wing method, 22
skin, 32–35
Smoke Alarm, 74–79
Snow Leopard, 138–41
The Starlet, 114–17
strip lashes, 28, 30
Sugar Plum, 56–59
Summer in the City, 64–67

T

tools, 14–16
Twiggy, 118–21

V

The Vacation, 48–51

W

Welcome to Miami, 106–9

MAKEUP BASICS

FACE CHART

Refer to this chart when re-creating the looks in *The Daily Face*. While it's true that every face is unique, our basic facial anatomy is the same. We all have cheekbones, eyelids, lips . . . you went to science class, you get the idea. Familiarizing yourself with the areas of the face will help you apply the correct product to the correct place. It doesn't matter if your face looks different from mine—or any of the faces in this book— you can still achieve these looks by using this chart.

At the same time, remember: all of our faces are different! And thank goodness, because it's what makes us unique and interesting, and it's how we tell each other apart. If we couldn't tell our best friend from our grandma, Nana would end up getting some information about your love life you'd *probably* rather she didn't have. It's important to keep individuality in mind while re-creating the looks in *The Daily Face*. No makeup look will appear exactly the same on two

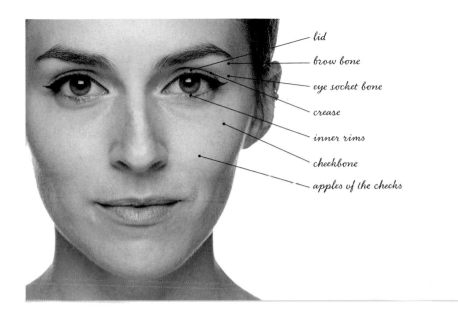

lid

brow bone

eye socket bone

crease

inner rims

cheekbone

apples of the cheeks

people, so don't get discouraged if you complete a look and you don't end up looking *exactly* like the photo. You might have smaller eyes than the faces in this book, or more pronounced cheekbones, bigger lips or thinner lips. Ultimately it doesn't matter. Each makeup look will be unique to you, because your face isn't like anyone else's. And that's why you're great.

TIP · *The Eye Socket Bone*

Put your fingers up to your eye area and start pressing lightly. You should touch your eye socket bone, which feels like a circle around your eye. The top part of the bone around your eyebrow is your brow bone. The lower part of that bone creates the crease in your eyelid. The eye socket bone and the brow bone are actually the same bone (I know it's a little confusing), but I refer to the brow bone as the protruding area of the brow arch (directly below your eyebrows themselves), while I use "eye socket bone" to refer to the area just above the crease in your lid. If I say to apply shadow along the eye socket bone, the product should not extend all the way up to the brow.

ESSENTIAL BRUSHES

Here are the six brushes I used to create every look in this book. Good brushes are expensive, but if you take care of them (see "Cleaning Brushes," facing page), they should last for years.

Brushes are made from either synthetic or natural hair. Synthetic makeup brushes are less expensive and don't have as long of a shelf life as their natural counterparts. Natural-hair makeup brushes are more expensive, but if you can spring for them, they are worth the investment. MAC and Make Up For Ever both make quality natural-hair brushes. However, if natural brushes are not in the budget, don't worry. Brands like Sephora make high-quality synthetic brushes that totally do the trick.

In each look in the book, I reference the appropriate brush for each step by the following names, so if you get confused, flip back over to this section to cross-reference with the photo.

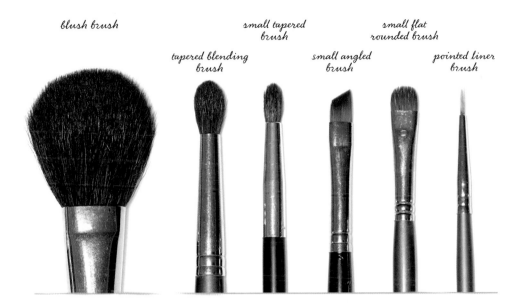

blush brush

tapered blending brush

small tapered brush

small angled brush

small flat rounded brush

pointed liner brush

Blush brush: For applying blush (obviously)

Tapered blending brush: For applying shadow to the lid area

Small tapered brush: For applying shadow with precision into the crease

Small angled brush: For applying gel liner

Small flat rounded brush: For precision application of shadow into the bottom lashes

Pointed liner brush: For making precision lines

CLEANING BRUSHES

For good brush hygiene, clean them after every use. I use the original gangster of brush cleaners, Cinema Secrets. It's the most widely used brush cleaner for makeup artists working in film and television, and is available at most beauty supply stores and online.

To clean your brush, pour a small amount (enough to cover all the bristles of the brush) of the cleaning solution into a glass container, such as a small juice glass or small mason jar. Wipe off any excess product from the brush, dip the brush into the cleaner for a few seconds, and wipe it dry on a paper towel. *Voilà!* For larger brushes, such as a blush brush, you can clean with shampoo and conditioner. Just wash the bristles as if you were washing your hair.

ADDITIONAL TOOLS

There are a few additional makeup tools to keep handy in your makeup bag. Some of them you'll use frequently (I use an eyelash curler every day), while some of them, such as the sponge applicator, you may only use for specialty costume looks. Either way, it is good to have these around.

Smudge brush: A small rounded "brush" used for smudging eyeliner, this tool has a small sponge on the end instead of bristles.

Sponge applicator: A latex sponge used for applying larger quantities of makeup over the entire face.

Tweezers: Most commonly used for grooming brows, but also useful for applying false eyelashes.

Eyelash curler: A device used for curling lashes. It looks painful, but I promise it isn't.

EYES

Ah, eyes, the windows into the soul. Yes, eyes are the medium through which you can express sadness and joy, or, more important, tell that girl flirting with your boyfriend to back off, because *seriously*, you mean business. Even without any other makeup, you can create an evening look, daytime look, or party look just with your eyes—eye makeup is truly the most versatile element of all makeup!

EYELINER

There are three types of eyeliner used in *The Daily Face*: pencil, gel, and liquid. I use each of the liners based on the desired effect. My personal favorite is gel liner, which I apply with a small angled brush (see page 15). I find gel eyeliners very easy to apply. Plus, they have great staying power, especially on the inner rims, where pencil and liquid liners can't hold as well. My favorite

gel eyeliner is Fluidline by MAC in the color Blacktrack. When re-creating the looks in this book, flip back to this section if you need a refresher on the different types of liner.

Pencil

Pencil liner will give you the softest line and is the most forgiving type of eyeliner for makeup novices. I recommend sharpening your pencil to a fine point every time you use it to ensure a clean, precise line.

> *Applying Pencil:* To apply pencil liner, you'll want to start at the inner corner and draw a line to the outer corner. You can do this in one movement or in small strokes—whatever feels comfortable. There isn't a right or wrong way to apply pencil liner as long as the end result is a smooth, straight line. For precision, it helps to pull the skin at the corner of your eyes slightly taut, though you never want to overstretch this delicate skin.

Gel

Gel liner is the happy medium between pencil and liquid. You can achieve a bolder, cleaner line than with a pencil, yet it is easier to apply than liquid. Gel generally has the best lasting power, which makes it my liner of choice.

> *Applying Gel:* Gel liner is applied with a small angled brush. This brush allows you to achieve a straight line along the lashes, and to create a fine point at the outer corner of the eye. Load the brush with product and then wipe it against the rim of the container so the makeup on the brush has a sharp edge. This will make it easier to achieve a fine line. Applying gel usually takes a bit of practice but is well worth the effort.

Liquid

Liquid liner will give you the darkest and boldest line and is great for dramatic eyes and mod-inspired looks. It is also the most difficult to apply, due to its somewhat unforgiving nature. Wavy lines and bumps will be easy to spot if

you don't apply with a steady hand. For best results with liquid liner, make sure the brush that comes with your liner is a sponge brush that forms a very fine point. You can also buy liquid liner in cake form, which looks like pressed powder and turns into liquid liner when you add water. You'll need a pointed liner brush if you use this type of product. If you're brave (and you should be brave!) and want to try liquid liner, I suggest using liquid liner from The Body Shop—no kidding, it's the best.

Applying Liquid: Apply liquid liner to your top lid along the lash line as straight as possible without making yourself crazy. Then take a damp Q-tip and drag it lightly along the top edge of the liquid liner. Make dramatic wings (See "Just Wing It," below) and use the Q-tip to get the tips of the wings super pointy. You'll need to use a liquid liner that is not waterproof for this trick to work, so don't test it out before watching *Titanic* alone on a Friday night.

TIP · *Apply Liner First*

When using a gel or liquid liner, I recommend applying the eyeliner first, followed by shadow. This prevents you from ruining your shadow if you can't get your liner perfect the first time and need to fix mistakes. I even follow this order when applying my own makeup. Just because I'm a makeup artist doesn't mean I never have to clean up a line or redo a wing! After I finish my eye shadow, I retrace over the liner so it's nice and dark.

Just Wing It

A slight wing is essential every time eyeliner is applied. You probably apply your makeup looking straight ahead in the mirror, right? Have you considered what your makeup looks like from a profile view? This is easy to forget, but the rest of the world sees your makeup from straight on *and* from the side, so it's

important to apply eyeliner in such a way that is flattering from both points of view. I want you to look glamorous from Every. Single. Angle.

Eyeliner that stops short right at the corner of your eye may seem fine when you are looking straight ahead in a mirror, but from a profile view, your eyes will appear small. Whether I'm doing my own makeup or someone else's, I always extend the liner slightly past the outer corner and draw the liner slightly upward. Doing so will give the eyes an elongated look from the side and draw the eye corners up for a nice, open effect.

I encounter many women who are too intimidated to try a winged liner. I understand—it takes practice and patience to master. Still, I believe that learning to do a solid cat eye is worth your time and energy. After all, it's one of the most glamorous and flattering looks you can wear. And remember, winged liner can be applied in varying degrees of severity. You can channel Brigitte Bardot with a dramatic '60s cat eye, or you can add a tiny lift to the end of any liner application. Just because you wing your liner doesn't mean you have to look like Twiggy every time you do it. Though if you ask me, that's also *perfectly* acceptable.

I've broken down winged eyeliner into three different styles. Try them all out on yourself. Find the style that looks best on your face and make that your go-to eyeliner style. I am using gel liner with an angled brush in all of these examples, but you can use pencil or liquid liner as you prefer. The same instructions apply for all types of eyeliner.

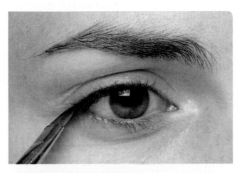

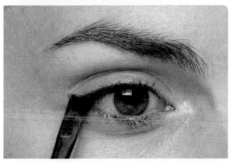

Natural Liner

Find the highest point on the arc of your lash line, which is directly above the center of your pupil. Now move a hair toward the outer corner of your eye, so you're barely past the highest point of the lid. This is where you will start your liner.

Trace a line outward, making it very thin extending from this point on your lid and thicker as it moves toward the outer corner of your eye. Stop there—you'll add the wing in the next step. Starting with a thin line means the product will blend fluidly with your lashes, instead of sitting on top of them.

Create a very small wing just past the outer corner of the eye. Start where you want the wing to end and move your brush inward to meet the first line at the outer corner of the eye; you are moving your brush in the opposite direction as your first line. Make sure the wing extends up slightly; this will give the illusion of the eye opening up.

TIP

To create any wing, I always start at the end point of the wing and work my way in toward the eyeliner line. This means you are moving the brush in the opposite direction as your first line. This technique helps create a fine point on the end of your wing.

The '60s Wing

Follow the steps for the Natural Liner (page 21), but start your liner all the way at the inner corner of the eyes, rather than the middle point.

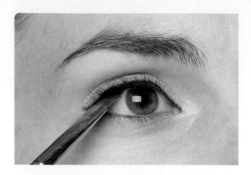

Next, line the inner rim of your top lid. This will close any gaps between your liner and lashes and create a nice, thick line.

Then, using the thin point of your eyeliner brush, draw a line from the outer corner of your eye moving upward and out past your eye on a 45- to 55-degree angle. This line will be the bottom edge of your wing and the tip will be the tip of your wing. The line will be a guide as you apply more liner for the wing.

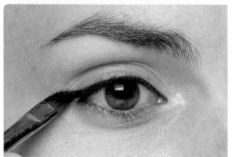

Starting from the outer tip of the wing line, apply liner moving inward until it meets the liner along the lash line. This may leave you with a sort of open wing at the outer corner of your eye, depending on your eye size and shape.

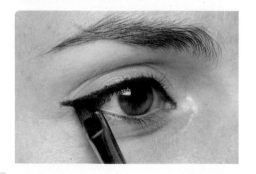

Fill in that wing and touch up areas that don't fully connect.

TIP

When I apply this style of eyeliner, I use short strokes to build up to the look. Once everything looks even, I extend the tip of the wing a little more. Leave the bottom of the eyes bare.

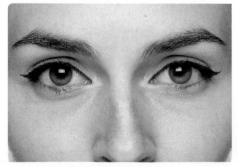

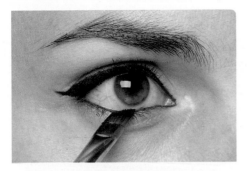

The Cleopatra

Follow the steps for the '60s Wing (facing page).

Line the inner rim of the lower lid from corner to corner. Now the inner rims of your lids are lined around your entire eye.

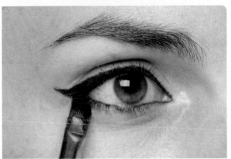

Start at the tip of your wing and apply liner toward your lower lid, until it flows fluidly into your lower lashes. Now the wing of your liner will extend from both the upper and lower lid, not just the upper lid like in the '60s Wing.

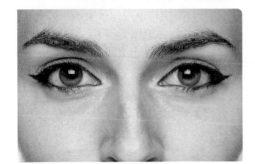

EYE SHADOW

Eye shadow is a quick, easy way to bring color to your eyes. It's important to keep in mind that eye shadow will look different on everyone due to the varying shapes and sizes of our eyes. The larger your eye area, the more shadow you'll be able to apply. If your eyes are small, you can wear the same colors and styles as someone with large eyes, but you should apply with a lighter touch. Should you have a monolid (no crease, as often seen in Asian eyes), you'll want to keep the dark colors close to your lash line and lighter colors higher up on the lid.

With practice you'll master what looks best on your face.

Powder Shadows

Powder shadows are the most common eye shadows and create a veil of color over the lids. They are slightly easier to blend than cream shadow since you don't have to worry about the product drying quickly on the lid.

Applying Powder Shadows: Powder shadows are most commonly applied with brushes. Though makeup artists carry tons of brushes, for my personal use I can achieve every eye shadow look with a tapered blending brush, a small tapered brush, and a flat rounded brush. I find it helps to raise my eyebrows as I apply powder shadow. This helps pull the skin around your eyes taut, allowing for smoother application.

Cream Shadows

Cream shadows usually result in more saturated color than powder shadows. It's best to work quickly when applying creams because they dry once applied and become difficult to blend. The drawback to cream shadow is that they crease in the lid more easily than powders. Look for cream shadows that say "creaseless" on the packaging.

Applying Cream Shadows: I generally apply cream shadow with my finger by dabbing and smoothing the product onto my lids. A small flat rounded brush can also be used in areas of the eye where your fingers might be too big, such as the inner corners.

LASHES

When I eventually stumble upon a magic genie lamp, my first wish will be for longer, perfectly curled eyelashes, because much to my chagrin, mine are very straight. Luckily, until that day, there are many ways to enhance eyelashes—curling, mascara, and even using false lashes. If you are one of those women genetically blessed with long, curled lashes, consider yourself lucky. I envy you!

(Also just to clarify, the lashes request would be my first wish *after* world peace. In case you're interested, my third wish would be for the power to become a mermaid when I enter water. With long, perfectly curled eyelashes, obviously.)

Mascara

If you were stranded on a desert island and you could only take one item of makeup, what would it be?

Did you say mascara? Is that your final answer?

Congratulations, *mascara* is CORRECT!

I bet a lot of you would bring concealer to the desert island, but I'll tell you why you shouldn't: No one notices the dark circles under your eyes and blemishes on your face as much as you do. I'm serious, your friends don't notice them, your boss probably doesn't notice them (if he does, he's impressed you are working so hard you can't sleep), and your significant other loves you too much to notice them. The fact is the only people who *do* notice your imperfections are those who might not like you (who cares what they think anyway?) and your ex's current girlfriend. In short, you are covering up your imperfections for a small minority of people. So instead of covering what you think is bad, why not accentuate what is really, really good: your eyelashes?

Using mascara can make your eyelashes look ten times thicker, darker, and longer than they are when bare, in turn, drawing attention away from your "imperfections" and toward your eyes. Also, mascara is buildable, meaning you can apply many coats, and your eyelashes will keep getting longer, thicker, and darker.

I occasionally have people say to me, "I'm so bad at applying makeup; I can't even put on mascara." Usually, I'm very sympathetic to the plight of the makeup-challenged, but this is one statement I refuse to accept. Can you write

your name with a pen? If so, I promise, you can apply mascara. It's actually quite foolproof. Plus, it only takes one minute to apply (even if you put on as many coats as I do), so you do have time to put it on before work, even when you wake up at the last possible second. I bet you can get at least one coat on in the elevator ride to your office.

So please, next time you are abandoned on a desert island and can only pack one item of makeup, bring mascara. I promise you'll look really good while you get that signal fire going.

> ***Applying Mascara:*** When applying mascara, it helps to angle your head up, with your eyes looking down; this pulls the lid skin taut and away from your lashes. Place the coated mascara brush at the base of your lashes and move it up to the ends. I personally believe that there is no limit on how many coats of mascara you can wear. If you like a natural look, use one coat, but if you prefer a more dramatic eye, then load it up! I usually wear about five coats of mascara. No joke.

> TIP · ***Getting Mascara Off Your Skin***
>
> Isn't it annoying when you beautifully apply all your makeup and then you accidentally get some mascara on your eyelid? When this happens, don't freak out and, most important, don't try to wipe it off. Wait a few minutes and let the mascara dry, then brush over it with a clean eye shadow brush. The mascara will flake right off!

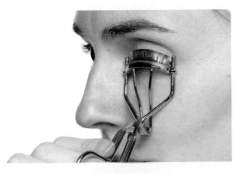

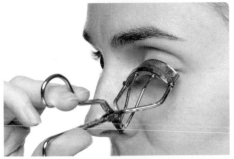

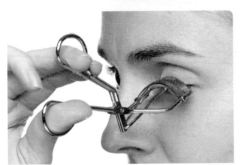

Curling Lashes

Contrary to appearances, an eyelash curler is not a torture device. It's actually really easy to use and can make your eyes appear much bigger and more awake. With eyelash curling, you want to avoid creating the severe right angle shape that comes with curling the lashes quickly and only in one spot. Instead you want to get a fluid C-curve by working the curler gradually up the lashes. I curl my lashes every time I put on makeup. If you wish to do this, too, I recommend curling your lashes first, before putting on any makeup.

. . .

Position the curler at the very base of the lashes, as close to the lid as possible, and make a compression, holding for a few seconds.

Move the entire lash curler (and your hand) slightly away from the first spot and make another compression, holding for a few seconds.

Now move the entire lash curler slightly away from the second spot and make yet another compression, holding for a few seconds.

Continue making compressions up the lashes until you have reached the top of the lashes.

. . .

Remember, you can go over your lashes with the curler as many times as you wish until you have achieved the desired curl. ALWAYS curl your lashes before applying mascara. Curling after mascara will clump the mascara together, and you run the risk of pulling out or breaking your lashes.

False Lashes

False lashes are one of man's greatest inventions, rivaled only by electricity and the Investigation Discovery channel. They're great for fancy events, parties, and batting your lashes at an attractive guy from across a room. They are inexpensive and can be found at any drugstore or beauty supply store. I like to use individual lashes instead of strip lashes because they make for a more natural look and I find them much easier to apply. If you're going for something a little over the top, go for strip lashes.

By "individual lashes" I mean the lashes that come in little bunches. Lashes that are simply one single lash are called "singles" and are an epic pain to apply. The only people who ever use those are professional makeup artists.

If you're buying false lashes, don't forget your lash glue! It will always be stocked with the false lashes in a store. My go-to brand is Duo.

Applying Individual False Lashes

MATERIALS *False lashes, eyelash glue, tweezers, eyelash curler (optional)*

. . .

Squirt a tiny dot (somewhere between the size of a pinhead and an eraser head) of lash glue onto the hand you won't be using to apply the lashes.

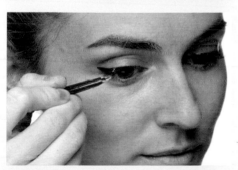

Hold the lashes container so the tips of the lashes are facing away from you. Using your tweezers, grab one lash bunch and pull it out of the container.

Holding with the tweezers, dip the clustered end of the lashes into the glue.

Still holding with the tweezers, gently place the false lashes on top of your own lashes. I usually start from the outer lashes and work my way in. Repeat until your lashes are filled in to your desired effect.

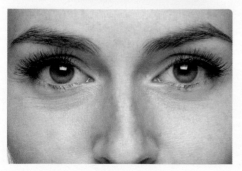

> **TIP**
>
> For a natural look, use tiny scissors to cut down a few of the lash bunches so they are shorter, then apply these to the inner corner of the eyes. If you look at your natural lashes, they get shorter as they move in; try to mimic that when you wear false lashes.

> **TIP**
>
> Lightly curl your lashes once your false lashes are applied and dry. This will allow your natural lashes to blend in.

Applying Strip Lashes

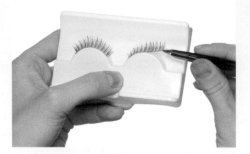

MATERIALS *False lashes, eyelash glue, tweezers, eyelash curler (optional)*

· · ·

Squirt an eraser-size dot of glue onto your nondominant hand.

Remove the lashes from the packaging, with either your fingers or tweezers. Do this gently so as not to crimp the lashes.

Hold the lashes between your fingers or with tweezers, and drag the strip that connects the lashes lightly through the glue so it is covered in glue from end to end.

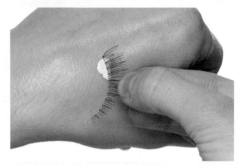

Place one end of the strip about one milli-meter in from the outer corner of your eye, not right at the corner.

Keeping the strip as close to your lash line as possible, press the lashes onto your lid moving toward the inner corner of your eye.

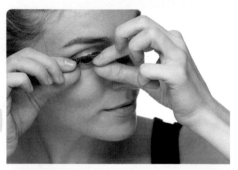

TIP

Strip lashes should not end right at the outer corner of the eye; this can make eyes look droopy. Instead, place the end of the strip about a millimeter in from the outer corner of the eye.

TIP

Try cutting your strip lashes in half and placing them only along the outer por-tion of the lashes.

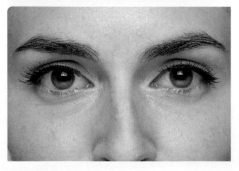

BROWS

Whether you have eyebrows like Bette Davis, or Brooke Shields circa 1983, it's a good idea to lightly groom them when applying your daily makeup. Grooming brows simply means getting rid of any stray hairs and filling in spots that might lack thickness. I recommend seeing a professional to get your brows shaped, because trust me: over-tweezed brows are *not* a nightmare you want to deal with. But filling them in is quick, easy, and something you can do yourself!

Those of you who have dark or thick brows to begin with (consider yourself lucky!) probably won't need to do any filling in. You might want to take a brow brush and comb brows lightly so the hairs fall in the same direction. For those of you (like me) who have some spotty areas in your brows, use a brow pencil or brow shadow to fill in the gaps, then lightly brush hairs with a brow brush for an even look.

Applying Brow Color: Whether you're using a brow pencil or brow shadow, the technique for filling in brows is the same. (I prefer brow pencils because it means one less brush to keep track of!) To fill your brows, first comb them with a brow brush. Then, using your pencil or shadow brush, fill in any spotty areas with short strokes in the direction your brows naturally grow. These strokes will mimic the look of your brow hairs and create a natural look.

SKIN

I'm a strong advocate against wearing foundation on a regular basis. I feel that anything chemical-based that covers your pores isn't healthy for your skin. Foundation should only be used for special occasions, or when you are having your photo taken, like at weddings and joke mall portrait sessions with your friends. Use concealer to cover problem areas, and, for slightly more coverage, use a tinted moisturizer to even out your skin tone. If you want to add some color to your face, blush and highlighters are a great way to brighten and contour your complexion. When choosing face products, it's important to be aware of the ingredients you're putting on your skin. I stay away from anything that contains parabens, which are common allergens.

TINTED MOISTURIZER

Tinted moisturizer is exactly what it sounds like: moisturizer with a tiny amount of foundation in it, just enough to tint the skin and lightly even out its tone. If you wear tinted moisturizer, I urge you to check out brands that use natural ingredients, such as Tarte or Josie Maran. Your skin will thank you for it.

Applying Tinted Moisturizer: You can apply tinted moisturizer with a sponge applicator or with your fingers. Cover the face evenly, just as you would with a regular moisturizer. Always make sure to blend the edges at your jawbone and neck.

CONCEALER

Concealer is probably the most debated product in the makeup community. Everyone has a differing opinion on how to pick the correct color for your skin tone. My rule of thumb is that concealer should be half a shade lighter than your natural skin tone.

The trick to concealer is choosing the correct undertones for your skin. Most concealers, just like colors, are categorized into "warm" and "cool" tones. That's because your skin either has a warm (pinkish/red) or cool (olive/yellow) tone. If you have olive skin, buy concealer with cool undertones. If you have pinkish skin, buy concealer with warm undertones. You want to match the undertone of your concealer to the undertone in your skin.

When buying concealer, don't be afraid to ask for help. People working in makeup stores know their stuff and will be able to steer you in the right direction. If you can, test the product in natural light. Ask a salesclerk for a handheld mirror and walk over to a window. If you are buying concealer from a drugstore, remembering the warm- and cool-tone rule will really help you. Most makeup companies differentiate between warm- and cool-toned products on the label. How nice of them to do the hard part for you! Of the high-end brands, Make Up For Ever HD Concealer is my favorite because it offers

great coverage and it is fragrance free, hypoallergenic, and has no parabens. For drugstore brands, L'Oréal True Match Concealer makes a wide range of shades with varying undertones.

One of my biggest pet peeves is when women don't change their concealer with the changing seasons. Your skin is usually a different shade in winter than in summer, so don't use the same concealer all year-round. Spring for a slightly darker shade when your skin is tan.

A common misconception is that if you wear concealer you also have to wear foundation. This is not true!

Applying Concealer: To apply concealer, whether to a blemish or to the undereye area, use your fingers and tap the product lightly onto the area until it is totally blended into your skin and there are no edges. You'll get the most natural coverage if you apply with your fingertips.

BLUSH

Is it the middle of winter? Do you uncannily resemble Casper the Friendly Ghost? Fear not; blush is the best way to add a natural burst of color to your face. With blush you can fake a tan, simulate a natural flush, or simply brighten up your sun-hungry winter skin. Not to say you can't wear blush all year-round. I just use it more in the winter, as opposed to the hot summer days with 100 percent humidity, and I get a natural flush just from the energy it takes to watch *Jeopardy*.

I prefer blush to look natural, so I stay away from bright pink shades, which can look a little clownish. (This is, however, a matter of personal opinion and isn't meant to steer you away from "statement blush" should you want to try it.) For a blush that looks natural on the skin, look for something matte with a brown undertone. Many blushes are formulated with shimmer in them. I prefer to keep my blushes matte and use a highlighter for added dimension; this allows me to concentrate shimmer on my cheekbones, without having it everywhere I put my blush, such as my forehead, chin, and bridge of my nose.

Powder Blush

Just like powder eye shadow, powder blush is pigmented pressed powder that leaves a veil of color on the skin. If you have oily skin, powder blush will work best for you.

Applying Powder Blush: Powder blush should be applied with a blush brush, starting from the apples of the cheeks and sweeping back toward the temples. It can also be applied under the cheekbones in the same sweeping motion to create contouring on the face.

Cheek Stains/Cream Blush

Cheek stains and cream blushes are liquid based. They are great for people with dry skin, as they will put some moisture back into the cheeks, giving you a dewy finish.

Applying Stains/Creams: Stains and creams are best applied with the fingers. Dab the product onto the apples of the cheeks and cheekbones and then blend the blush into the skin with your finger. The warmth of your skin will help blend the product into your cheeks.

Highlighter

Highlighter is used to add shimmer and dimension to the cheekbones, or any other areas you may want to catch light, such as the inner corners of the eyes or the bow of the lips. Most highlighters come in pencil, cream, or liquid form.

Applying Highlighter: Highlighter is applied just like cream blush and cheek stain, by dabbing the product onto the desired area and then blending with your fingers. If you are using a pencil highlighter, sweep the product across the desired area and then blend it into your skin with your fingers.

LIPS

I have a confession to make about lipstick: I don't really like wearing it. Somewhere along the way, I got it in my head that lipstick looked weird on me, and after that it became my least favorite makeup. There are two good lessons in this story:

1. Don't feel obligated to commit to every type of makeup. It's okay if something just isn't your thing.

2. Just because you think something looks weird on you doesn't mean you should swear it off forever. Experiment! Sure, I always feel a little weird in lipstick, but that doesn't mean I'm never going to wear it.

The best part about makeup is that you get to choose what works for you. Your makeup won't be any less successful if you decide you'd rather wear lip balm than lip gloss. (I do this literally every day. Except for the days when I am fearless and wear lipstick, of course.)

Lip color can be achieved with lipstick, lip pencils, or gloss. Adding lip color brings an extra element of drama to an evening look, but don't be fooled— lip color isn't just for fancy parties. One of my favorite looks for daytime is a bright lip paired with mascara (see page 64).

LIPSTICK

Lipstick comes in a variety of finishes and opacities: matte, semimatte, satin, and sheer. Matte lipsticks have no shine, while sheer lipstick, on the opposite side of the spectrum, is more like a pigmented gloss. Play around with the different types of lipstick to determine which you prefer.

> *Applying Lipstick:* I usually apply lipstick right from the tube. It's fast and easy to do when you're out and need to reapply. If you want to get fancy, lipstick can also be applied with a lip brush. This gives you a little more control and allows you to be more precise with your placement.

LIP PENCIL

Lip pencils help to finish the edges of your lipstick so it doesn't bleed above your lips. When wearing dark lipstick, it's important to use a lip liner to create a perfectly defined line. Occasionally, I use lip pencils as lipstick, by first applying a layer of lip balm and then filling in my lips with the pencil.

> *Applying Lip Pencil:* Trace the shape of the mouth with the lip pencil and blend the color in toward the center of the lips. This will prevent a hard line from being visible around your lips. You never want it to *look* like you are wearing lip liner. After you apply your lipstick, go back in with the liner and touch up your edges.

GLOSS

Lip gloss has a very sheer, glossy finish that will give your lips a wet look. Colored lip gloss is normally less opaque than lipstick.

> *Applying Gloss:* Apply lip gloss as you would your lipstick.

DAYTIME LOOKS

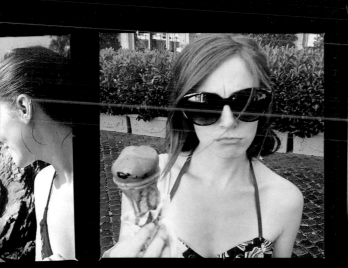

the

AFTERNOON DATE

Have you ever gone on a day date? I have, and I think they're great; much more casual than their nighttime counterparts. The tricky thing about a day date is deciding what to wear and how to do your makeup. Do you go super-casual? Do you wear a cute sundress? Usually the best route is something in between, and I created this look with that goal in mind. It says, "I tried! But not super-hard." You won't look like one of the Real Housewives trying to do sports if your day turns active. On the flip side, if the day date becomes a night date, you can easily walk into a nice restaurant without thinking, "Oh, man, I wish I'd had a few minutes to put on some makeup!"

MAKEUP

EYELINER Metallic brown or bronze pencil liner
Shown: Tarte Skinny SmolderEYES in Sunstone Bronze

EYE SHADOW Beige-pink cream shadow
Shown: Benefit Creaseless Cream Shadow in Bikini-tini

EYELASHES Black mascara
Shown: L'Oréal Carbon Black Voluminous Mascara

CHEEKS Soft rose cream blush or cheek stain
Shown: Tarte Cheek Stain in Loving

LIPS Lip balm

BRUSHES/TOOLS

Smudge sponge

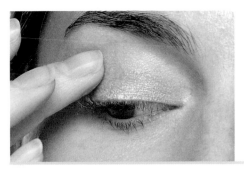

With your finger, apply beige-pink cream shadow to the lids, from the lash line up, blending into the crease. **STEP ONE**

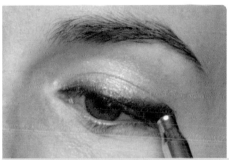

Apply the liner to the top lash line using the Natural Liner method (see page 21). Blend the top using the smudge sponge until there are no hard lines and the liner fades into the shadow. Do not overblend close to the lash line; you want this area to be the most pigmented. **STEP TWO**

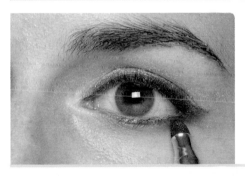

Apply the same liner into the lower lash line and blend lightly with the smudge sponge. **STEP THREE**

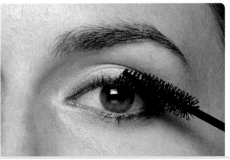

Apply mascara. **STEP FOUR**

CONTINUED

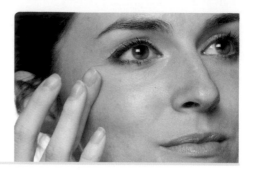

STEP FIVE With your fingers, apply cheek stain to the apples of the cheeks and blend back toward your temples.

Apply cheek stain or cream blush like you would concealer—by tapping the product onto your cheeks first and then blending away the edges.

TIP

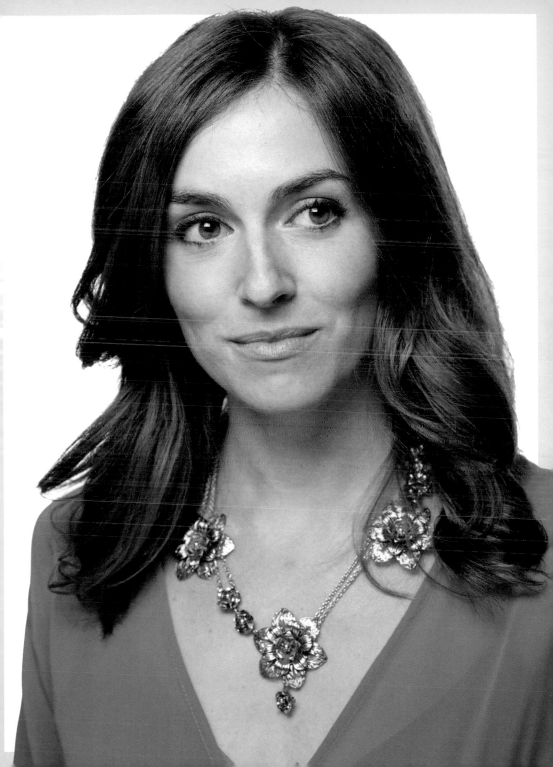

PRETTY in PINK

The best way to wear bright lips is with hardly any other makeup at all. I think this is a great daytime look, especially for summer, but let's just say hypothetically you lose track of time watching crime shows and you have no time to change your look before your evening plans. Do. Not. Fret. This look transitions perfectly to evening!*

**I'll stress that this is a totally hypothetical situation that has never happened to me. Never.*

MAKEUP

EYELINER Black gel liner
Shown: MAC Fluidline in Blacktrack

EYE SHADOW Copper-toned cream shadow
Shown: Benefit Creaseless Cream Shadow in My Two Cents

EYELASHES Black mascara
Shown: L'Oréal Carbon Black Voluminous Mascara

CHEEKS Gold-toned cream highlighter
Shown: Benefit Sun Beam

LIPS Fuchsia lipstick
Shown: NARS Semi Matte Lipstick in Funny Face

BRUSHES/TOOLS

Small angled brush

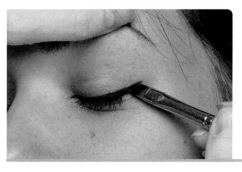

Using the '60s Wing method (see page 22) and a small angled brush, apply a thin line of black gel liner to the top lids. Also line the top inner rims.

STEP ONE

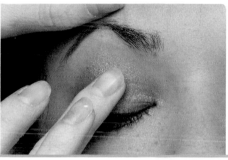

With your finger, apply a light layer of copper-toned cream shadow to the lid from the liner up to the crease. Blend at the crease so there are no hard lines.

STEP TWO

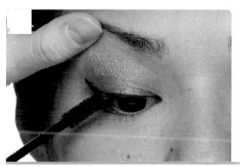

Apply mascara.

STEP THREE

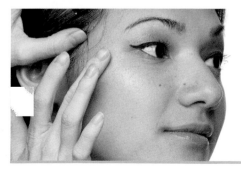

Using your fingers, blend a little bit of gold-toned cream highlighter onto the top of the cheekbones.

STEP FOUR

CONTINUED

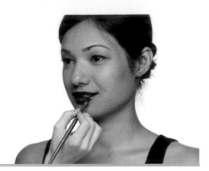

STEP FIVE Apply fuchsia lipstick.

STEP SIX Kiss a piece of paper and send it to the person you like the most.*

TIP

Remember that bright pink lipstick can make teeth look a little yellow, so be confident about your pearly whites when wearing this look.

That's just for fun.

THE
VACATION

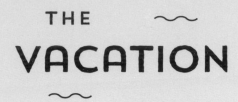

Let's say you're on vacation and you want to put minimal effort into your makeup. After all, you have sights to see, and the Roman ruins have been awaiting your arrival for literally almost two thousand years. The problem is, you also want to look good in all your photos. So, you can either wear sunglasses and throw some heavy filters on your Instagram pics, or you can take ten minutes to follow these steps. The soft peach tones of your naturally flushed skin (natural thanks to blush, of course!) will have people complimenting how relaxed and healthy you look instead of saying it's too bad you didn't get a shot of the Eiffel Tower without your face in it.

MAKEUP

EYELINER Black gel liner
 Shown: MAC Fluidline in Blacktrack

EYE SHADOW None

EYELASHES Black mascara
 Shown: L'Oréal Carbon Black Voluminous Mascara

CHEEKS Matte coral-brown powder blush
 Shown: MAC Powder Blush in Melba

LIPS Soft pink lip gloss
 Shown: Tarte LipSurgence Lip Tint in Charmed

BRUSHES/TOOLS

Small angled brush

Blush brush

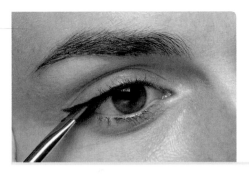

Using the Natural Liner method (see page 21) and a small angled brush, apply black gel liner to the top lid.

STEP ONE

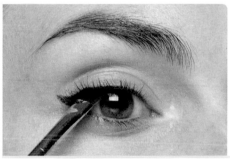

Apply black gel liner to the inner rims of the top lids, and lightly to the very outer corners of the inner rims of the bottom lids.

STEP TWO

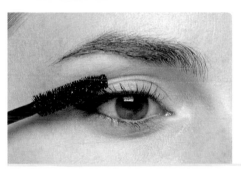

Apply mascara,

STEP THREE

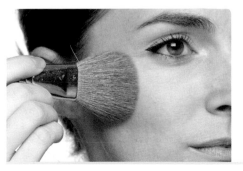

With a blush brush, apply matte coral-brown powder blush to all the places on your face that would be naturally tanned by the sun: the apples of the cheeks and cheekbones, the top of the forehead, the nose, and the chin. Essentially, you're giving yourself a mini fake tan with blush.

STEP FOUR

CONTINUED

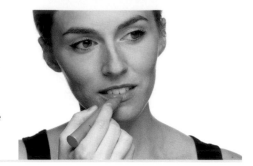

STEP FIVE

Apply soft pink lip gloss. Choose one that's easy to carry around and reapply.

I recommend making sure your brows are well-groomed with this look. It will add an extra-polished feel to otherwise minimal makeup.

TIP

EMERALD
City

No one wants to put on eye shadow every day. It's important to have an arsenal of liner-only looks for those days when you're running short on time, want a more casual look, or just don't feel like getting eye shadow out of your makeup bag (a perfectly valid excuse and one I use often). Colored liner is a great way to add an extra pop to your look. I love a deep emerald liner because it's subtle. From afar this liner looks casual, but up close you'll make people say, "Ooooooo!" (And you'll do so with very minimal effort.)

MAKEUP

EYELINER Emerald green pencil liner, black gel liner
Shown: Tarte Skinny SmolderEYES in Emerald, MAC Fluidline in Blacktrack

EYE SHADOW None

EYELASHES Black mascara
Shown: L'Oréal Carbon Black Voluminous Mascara

CHEEKS Bare

LIPS Rose lip gloss
Shown: Tarte LipSurgence Lip Tint in Charmed and Enchanted

BRUSHES/TOOLS

Small angled brush

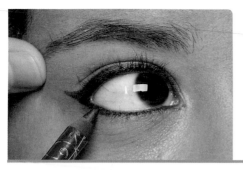

Apply emerald green pencil liner following the Cleopatra method (see page 23).

STEP ONE

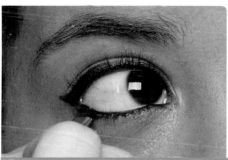

Apply black gel liner to the entire inner rims of the upper and lower lids using a small angled brush.

STEP TWO

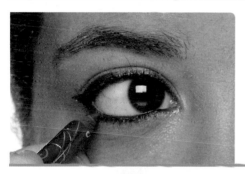

Apply emerald green liner to the inner rims of the lower lids, over the black liner.

STEP THREE

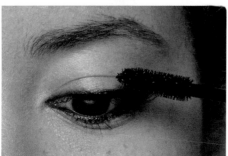

Apply mascara.

STEP FOUR

CONTINUED

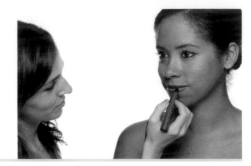

STEP FIVE Apply rose lip gloss.

When using colored liners on the inner rims, I like putting black liner down first because it has great staying power in this area of the eye and will help the colored liner last longer.

Sugar Plum

This is a great all-purpose look appropriate for work, the weekend, or even a date. It's casual and minimalistic, yet the gold shadow adds a little glamour. This is also a perfect transition look, meaning you can easily go from day to evening without making any adjustments. You can literally go anywhere in this makeup. Except to bed—never wear your makeup to bed!

MAKEUP

EYELINER Dark brown pencil liner
Shown: Tarte Skinny SmolderEYES in Moonstone Brown

EYE SHADOW Rose-gold eye shadow, deep berry eye shadow, shimmery gold eye shadow
Shown: NARS Duo Eye Shadow in Kuala Lumpur, MAC Eye Shadow in Goldenrod

EYELASHES Black mascara
Shown: L'Oréal Carbon Black Voluminous Mascara

CHEEKS Copper-toned cream highlighter
Shown: MAC Cream Colour Base in Improper Copper

LIPS Pink lip gloss (choose light pink if you are fair or a slightly darker pink if you have a darker complexion)
Shown: Tarte LipSurgence Lip Tint in Charmed

BRUSHES/TOOLS

Tapered blending brush

Small tapered brush

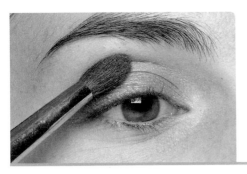

Using a tapered blending brush, apply rose-gold eye shadow to the lid from the lash line to the crease.

STEP ONE

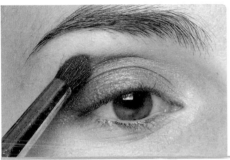

With a small tapered brush, apply deep berry eye shadow to the outer corners of the top lid and blend into and slightly above the crease.

STEP TWO

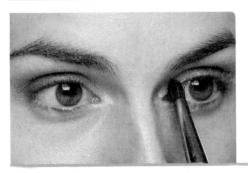

Use the small tapered brush to apply shimmery gold eye shadow to the inner corners of the lids and blend well into the light rose-gold shadow. Wrap the shimmery gold shadow lightly around the very inner corner of the eye, but there is no need to take it too far onto your lower lash line.

STEP THREE

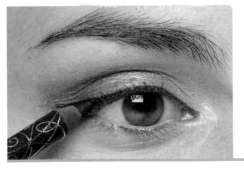

Using the Natural Liner method (see page 21), apply dark brown pencil liner to the outer corners of the top lid.

STEP FOUR

CONTINUED

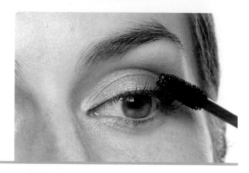

STEP FIVE Apply mascara.

STEP SIX Using your fingers, apply copper-toned cream highlighter to the cheekbones and blend it into your skin.

STEP SEVEN Apply pink lip gloss.

GOLD
-DAY-

I find gold tones universally flattering; that's why I recommend that makeup beginners test the waters with bronze and gold eye shadows. This look is a bit on the avant-garde side, but remember it's within your power to tone it down or play it up, depending on your mood. You can try applying less gold shadow or just skip that step altogether. (Though seriously, have some courage. It's just makeup; it won't bite!) No matter how gold you go, this look will complement any skin tone.

MAKEUP

EYELINER Black gel liner, metallic gold pencil liner
Shown: MAC Fluidline in Blacktrack, Make Up For Ever Aqua Eyes Pencil in Bronze (#10L)

EYE SHADOW Gold cream shadow
Shown: Make Up For Ever Aqua Cream in Gold (#11)

EYELASHES Black mascara
Shown: L'Oréal Carbon Black Voluminous Mascara

CHEEKS Matte rose-beige or rose-brown blush
Shown: MAC Powder Blush in Harmony

LIPS Bare

BRUSHES/TOOLS

Small angled brush

Flat rounded brush

Blush brush

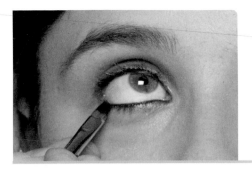

Apply black gel liner to the upper and lower inner rims of the lids.

STEP ONE

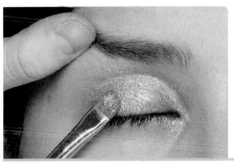

Using a flat rounded brush, apply gold cream shadow to the lash line and blend to above the crease.

STEP TWO

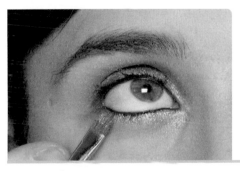

With the same brush, apply gold cream shadow under the lower lash line from inner to outer corner.

STEP THREE

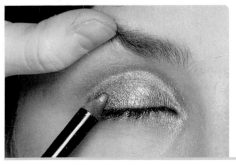

Apply metallic gold pencil liner around the entire eye. This step doesn't utilize the eyeliner methods from the Makeup Basics chapter. Instead, you want to shade the lids close to the lash line, as if you were applying the liner as a shadow.

STEP FOUR

CONTINUED

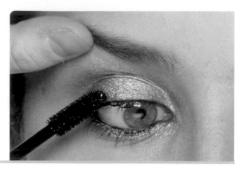

STEP FIVE Apply lots of mascara.

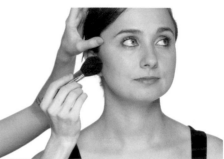

STEP SIX Sweep a touch of matte rose-beige blush under the cheekbones with the blush brush. I recommend using a brown-based shade instead of a pink shade, which can clash with gold eyes.

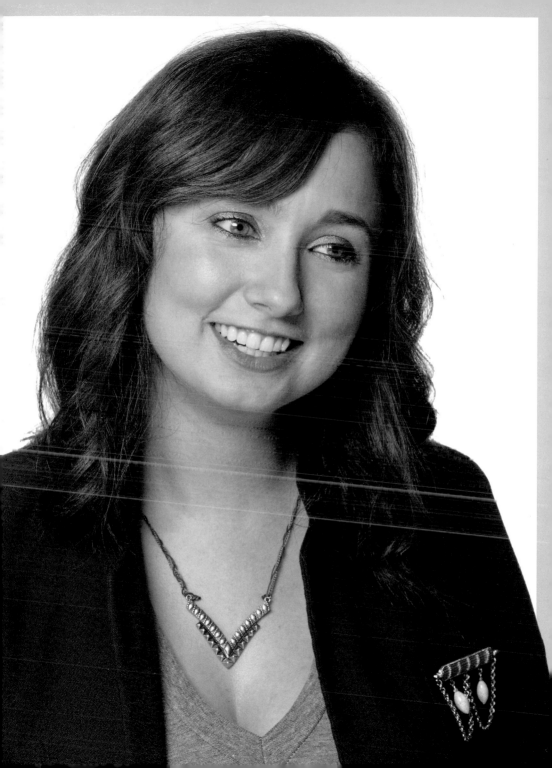

SUMMER IN THE CITY

I think a lot of women believe that red lips are for nighttime only. Don't sell red lipstick short—that hurts its feelings! Sure, a red lip will add dramatic glamour to any party look, but don't underestimate its power at the office or merely running errands. After all, who says you can't turn heads while buying ripe vegetables? (By the way, I tried this look on my dog, Petunia, but she said it made her look "too good" and made me take it off.)

Similarly to bright pink lips, red lips look best worn with minimal other makeup. Think of it as creating a "statement piece" with your mouth. The best thing to do is focus a little extra attention on grooming and shaping your brows, which can pull a minimal look together and give it a nice, polished feel.

MAKEUP

EYELINER None

EYE SHADOW None

BROWS Brow pencil to match your brow color
Shown: Benefit Instant Brow Pencil in Deep

EYELASHES Black mascara
Shown: L'Oréal Carbon Black Voluminous Mascara

CHEEKS Matte rose-beige or rose-brown blush (depending on your skin color; rose-brown works better for darker tones)
Shown: MAC Powder Blush in Harmony

LIPS Cherry red lip pencil, matte orange-red lipstick
Shown: NARS Lip Liner Pencil in Jungle Red, NARS Semi Matte Lipstick in Heat Wave

BRUSHES/TOOLS

Brow brush

Blush brush

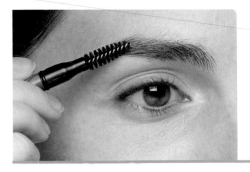

Groom your brows with a brow brush and fill in with brow pencil (see page 31).

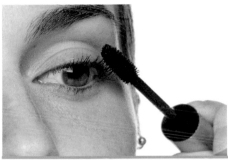

Apply mascara.

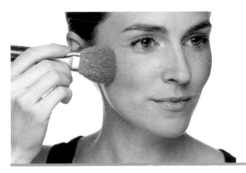

Using a blush brush, apply matte rose-beige blush to the apples of the cheeks, sweeping the brush back toward your temples.

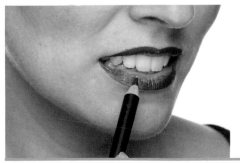

Line the lips with cherry red lip pencil but blend the liner into the lips so there isn't a hard line around your mouth.

CONTINUED

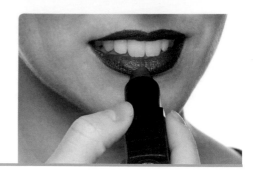

STEP FIVE

Apply matte orange-red lipstick over the liner. Then go back in with the liner to clean up the edges so the line is crisp.

TIP

Put a touch of hairspray on your brow brush when grooming so the hairs will stay in place.

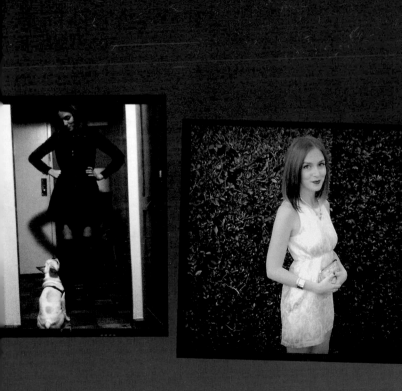

EVENING LOOKS

There is no better red lipstick than a Tom Ford red. Unfortunately, it is quite expensive. To get this look without having to live on instant mac and cheese for three weeks, use a less-expensive red of your choice and then find a super-shiny lip gloss to apply on top. (Also, just being straight, eating mac and cheese for three weeks sounds delicious to me and is nothing to be ashamed of.) This is a '50s-inspired look, so stay away from shimmery shadows and go with matte instead.

MAKEUP

EYELINER Black gel liner
Shown: MAC Fluidline in Blacktrack

EYE SHADOW Light beige matte eye shadow, soft neutral brown matte eye shadow
Shown: Bobbi Brown Eyeshadow in Bone, NARS Matte Eye Shadow in Blondie

EYELASHES Black mascara
Shown: L'Oréal Carbon Black Voluminous Mascara

CHEEKS Bare

LIPS Red lipstick, ultra-shiny clear or red lip gloss, red lip liner (optional)
Shown: Tom Ford Lip Color in Wild Ginger, MAC LipGlass in Clear, NARS Lip Liner Pencil in Jungle Red

BRUSHES/TOOLS

Small angled brush

Tapered blending brush

Small flat rounded brush

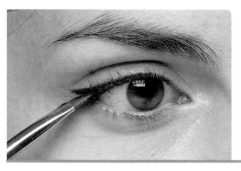

With a small angled brush, apply black gel liner using the Natural Liner method (see page 21). You might want to give the liner a little extra wing to give the eye an added lift.

STEP ONE

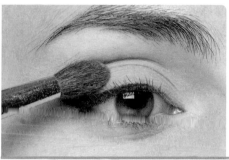

Using a tapered blending brush, apply light beige matte eye shadow to the entire lid from lash line to brow.

STEP TWO

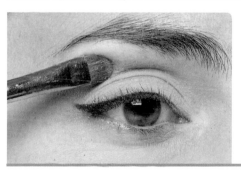

Using a small flat rounded brush, press neutral brown matte eye shadow onto the eye socket bone, in and slightly above the crease. This placement is important so the shadow is visible when your eyes are open. Make sure to blend the shadow well up toward your brows, so there are no hard edges.

STEP THREE

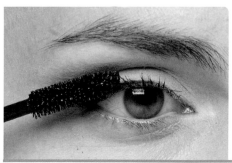

Apply lots of mascara.

STEP FOUR

CONTINUED

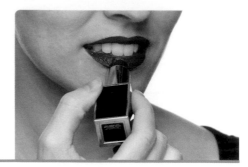

STEP FIVE Apply red lipstick.

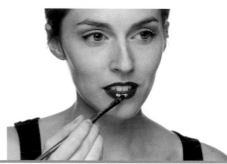

STEP SIX Finish off your lips with ultra-shiny gloss.

When wearing bold lipstick, it's always a good idea to go over the edges with a lip liner of the same color. This ensures crisp, clean lines. I often like to line lips with a liner that's a slightly darker color than the lipstick, as this will add dimension to the lips. Should you choose to do this, make sure to blend your liner into your lipstick well so you don't have a dark ring of liner around your lips.

TIP

Smoke Alarm

If you wear makeup, you have to know how to create a classic smoky eye—it's just a beauty requirement. You can achieve the smoky eye effect with any color, but classically it's done with grays and blacks. Don't be afraid of using dark colors in your smoky eye, but keep in mind that some faces can handle more makeup than others. If you have small eyes you will want to be extra careful with your shadow usage. This is something you'll only be able to figure out through experimentation. Try out this look multiple times with varying degree of smoky eye drama and then decide which looks best on you!

MAKEUP

EYELINER Black gel liner, highlighter pencil
Shown: MAC Fluidline in Blacktrack, NARS Soft Touch Shadow Pencil in Hollywoodland

EYE SHADOW Light silver-gray eye shadow, dark charcoal eye shadow
Shown: MAC Eyeshadow in Electra, NARS Duo Eye Shadow in Eurydice

EYELASHES Black mascara
Shown: L'Oréal Carbon Black Voluminous Mascara

CHEEKS Matte soft pink-bronze blush
Shown: Laura Mercier Second Skin Cheek Colour in Honey Mocha

LIPS Bare

BRUSHES/TOOLS

Small angled brush

Tapered blending brush

Small tapered brush

Small flat rounded brush

Blush brush

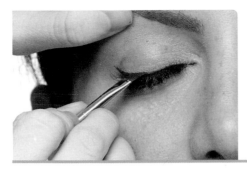

Using a small angled brush, line the upper lid with black gel liner using the Natural Liner method (see page 21). Line the upper and lower inner rims as well.

STEP ONE

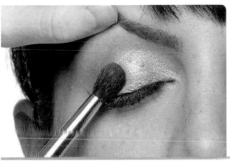

Using a tapered blending brush, apply light silver-gray eye shadow to the lids, diffusing the color slightly above the crease.

STEP TWO

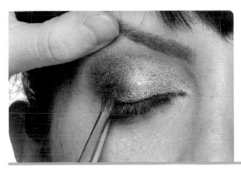

Using a small tapered brush, blend dark charcoal eye shadow onto the outer portion of the lids, from the lash line, blending up into the crease.

STEP THREE

CONTINUED

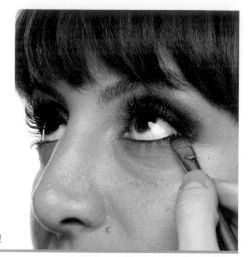

STEP FOUR — Using a small flat rounded brush, blend the shadow so it wraps around the outer corners of the eyes and extends below the lower lash line. You can take this shadow as far in as you wish; the farther toward the inner corners of your eyes you go, the more dramatic the look will be. Use the point of the small tapered brush to do this. The shadow on the lower and upper lid should connect around the outer corner of the eye. This is what makes a smoky eye, so don't skip this step!

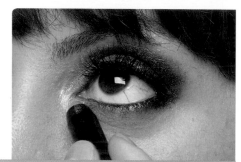

STEP FIVE — Dab highlighter pencil in the inner corners of the eyes and blend with your finger or a Q-tip.

STEP SIX — Apply matte soft pink-bronze blush lightly to the apples of the cheeks and cheekbones with a blush brush.

CONTINUED

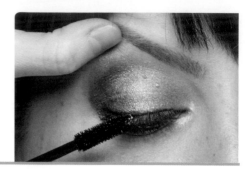

STEP SEVEN Apply mascara.

TIP

The trick to the smoky eye is a lot of blending, so don't be afraid to go over the shadow a lot with the brush. Take care not to extend the deep charcoal shadow too far toward the inner corner of the eyes; you want to see that light silvery-gray tone of the other shadow underneath.

TIP

If you're feeling really fancy, dab the highlighter pencil along the brow bone under the eyebrow arch, but be careful, as it's easy to get into drag-queen territory with a smoky eye. On the flip side, if you actually are a drag queen there's no need to be careful: use tons of highlighter on your brow bone; also, thank you for buying this book!

LITTLE ODESSA

This is one of my favorite looks; it radiates elegance and mystery. It says "I go to the opera, I read Dostoevsky; perhaps I am a spy." You know, all of those things that would be true about you if they didn't take too long to accomplish. This is a great look if you have small eyes. The lightness around the inner corners, coupled with the roundness of the darker shadow, opens up the eye area, creating the illusion of larger eyes. The deep lip makes this look dramatic, but if you're not feeling the dark lipstick, try it without. It looks great with a nude lip as well.

MAKEUP

EYELINER None

EYE SHADOW Light shimmery taupe cream shadow, espresso-brown matte eye shadow, shimmery white cream highlighter
Shown: Benefit Creaseless Cream Shadow in Birthday Suit, Bobbi Brown Eyeshadow in Slate, MAC Cream Colour Base in Luna

EYELASHES Black mascara
Shown: L'Oréal Carbon Black Voluminous Mascara

CHEEKS Soft pink cream blush
Shown: MAC Cremeblend Blush in Ladyblush

LIPS Deep burgundy lipstick
Shown: MAC Lip Mix in Burgundy

BRUSHES/TOOLS

Small tapered brush

Small flat rounded brush

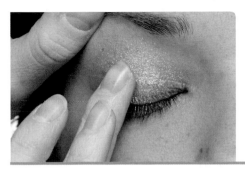

Using your finger, apply light shimmery taupe cream shadow to the lids, from lash line to crease. **STEP ONE**

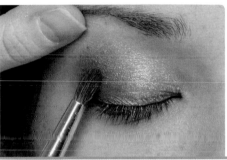

Using a small tapered brush, apply espresso-brown matte eye shadow to the outer corners of the top lids and wrapping around the outer corner to the lower lash line. Create a drop shadow with this shadow along the outer corners of the lower lash line. **STEP TWO**

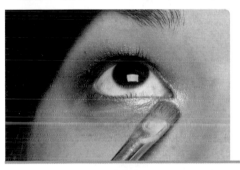

With your finger, or a small flat rounded brush, apply shimmery white cream highlighter to the inner corners of the eyes. Blend where it meets the taupe shadow on both the top and the bottom. **STEP THREE**

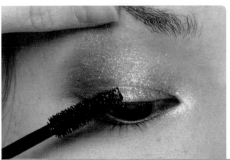

Apply mascara. **STEP FOUR**

CONTINUED

STEP FIVE Using your fingers, lightly apply a small amount of soft pink cream blush to the apples of the cheeks.

STEP SIX Apply deep burgundy lipstick.

As with all dark lipsticks, I recommend applying a lip liner to the edges of your lipstick so the line is crisp.

TIP

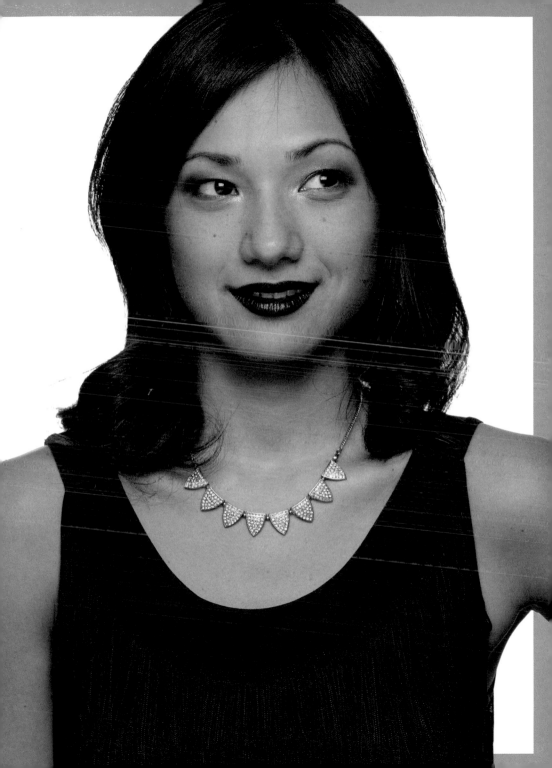

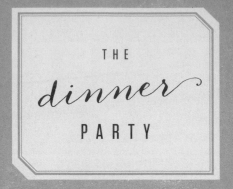

THE

dinner

PARTY

This might be my favorite look in The Daily Face. It's also the most versatile. It's my go-to makeup for any dressy affair, such as a wedding or a dinner party, where I want to look fancy, but not too fancy. People will notice this makeup, and you will be showered with compliments (get used to it), but you won't look like you're trying to grab attention or outdo your host. Leaving the lips nude is the trick here. Keep it light and let your eyes do the work.

MAKEUP

EYELINER Black liquid liner, pearl-gold highlighter pencil
Shown: The Body Shop Liquid Eyeliner in Black, NARS Soft Touch Shadow Pencil in Hollywoodland

EYE SHADOW Light pink matte eye shadow, soft gray-brown matte eye shadow
Shown: Benefit Longwear Powder Shadow in Pinky Swear, NARS Duo Eye Shadow in Bellissima

EYELASHES Black mascara
Shown: L'Oréal Carbon Black Voluminous Mascara

CHEEKS Matte soft pink-bronze powder blush, gold or warm-toned highlighter
Shown: Laura Mercier Second Skin Cheek Colour in Honey Mocha, Benefit Sun Beam Highlighter

LIPS Lip balm

BRUSHES/TOOLS

Tapered blending brush

Small tapered brush

Blush brush

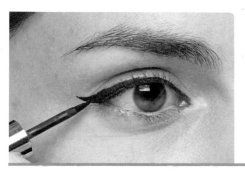

With black liquid liner, line the top lids using the '60s Wing method (see page 22). **STEP ONE**

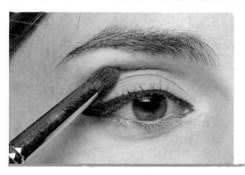

Using a tapered blending brush, apply light pink matte eye shadow to the lid from liner to crease, and blend. **STEP TWO**

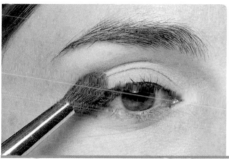

With a small tapered brush, apply gray-brown matte eye shadow into the crease of the eye, and blend softly into the eye socket bone, slightly above the crease. **STEP THREE**

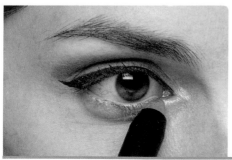

Apply pearl-gold highlighter pencil to the inner corners of the eyes, wrapping around the corners. Blend the edges of the highlighter with your finger or a Q-tip. **STEP FOUR**

CONTINUED

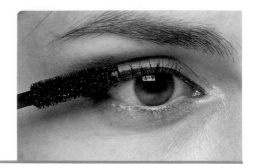

STEP FIVE

Apply lots of mascara and lip balm. What else is new?

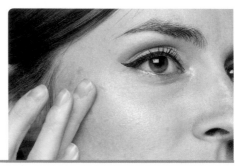

STEP SIX

Using your finger, apply gold highlighter to the tops of the cheekbones and blend into your skin toward your temples.

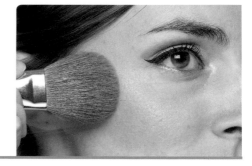

STEP SEVEN

Apply matte soft pink-bronze powder blush to the cheek- bones using a blush brush.

TIP

The Body Shop liner is a great liquid liner if you are a beginner. Why? Because it's not waterproof, meaning you can apply it and then shape it easily with a damp Q-tip. I apply liquid liner before shadow, so I can make adjustments to it without messing up the rest of my makeup. You can always go back over the liner once your shadow is applied.

grape juice

A lot of people ask me what shadow colors they should or shouldn't wear with their specific eye color. I usually respond by asking them why they want to make rules for themselves. I mean, isn't it generally more fun not to have rules? Don't limit yourself to certain colors because someone once told you green-eyed people shouldn't wear blue-toned shadow. That said, there are certain combinations that will make eye color really pop. I absolutely love a grapey-purple shadow with blue eyes. It draws all the attention straight to the center of your face. And if on top of that you also happen to have blonde hair—forget it! The world may not even be able to handle how elegant you will look.

MAKEUP

EYELINER Black gel liner
Shown: MAC Fluidline in Blacktrack

EYE SHADOW Light beige matte eye shadow, deep berry eye shadow
Shown: Bobbi Brown Eyeshadow in Bone, Christian Dior 5-Colour Eyeshadow palette in Stylish Move—Deep Eggplant

EYELASHES Black mascara
Shown: L'Oréal Carbon Black Voluminous Mascara

CHEEKS Matte soft pink blush
Shown: MAC Powder Blush in Mocha

LIPS Raspberry-pink lip gloss
Shown: NARS Larger Than Life Lip Gloss in Penny Arcade

BRUSHES/TOOLS

Small angled brush

Tapered blending brush

Small tapered brush

Blush brush

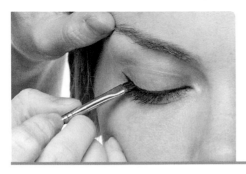

Using a small angled brush, apply black gel liner to the top lids using the '60s Wing method (see page 22). **STEP ONE**

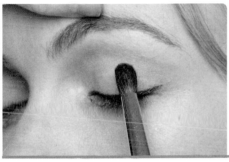

With a tapered blending brush, apply light beige matte eye shadow to the lids from the liner to the crease. **STEP TWO**

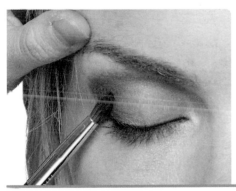

Using a small tapered brush, apply deep berry eye shadow to the outer portion of the lid from the lash line, blending into and slightly above the crease. Blend the product so the berry shadow fades seamlessly into the light beige shadow as you move inward. In the crease, blend the shadow all the way in toward the inner corner of the brows. **STEP THREE**

CONTINUED

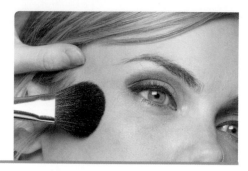

STEP FOUR — Using a blush brush, sweep matte soft pink blush lightly onto the cheekbones.

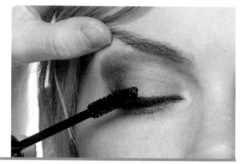

STEP FIVE — Apply mascara.

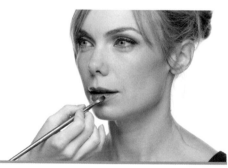

STEP SIX — Apply raspberry-pink lip gloss lightly to the lips.

BROOKLYN
N I G H T S

There are a few makeup looks every girl should have in her arsenal—one of them being a strong, dark, eye-focused look, worthy of raging in some dark warehouse in Brooklyn or going to a fancy dinner party. This is my "dark party" look. I've worn it everywhere from New Year's Eve bashes to formal events.

When wearing a dark eye, I recommend keeping the rest of your makeup minimal; otherwise your look can become costumey. Ditch the lipstick on this one. It allows your eyes to stand out more—plus, it's one less thing to carry in your bag.

MAKEUP

EYELINER Black gel liner
Shown: MAC Fluidline in Blacktrack

EYE SHADOW Deep black eye shadow, dark graphite eye shadow
Shown: SugarPill Pressed Eyeshadow in Bulletproof, NARS Duo Eye Shadow in Eurydice

EYELASHES Black mascara
Shown: L'Oréal Carbon Black Voluminous Mascara

CHEEKS Soft pink cream blush
Shown: Tarte Cheek Stain in True Love

LIPS Lip balm

BRUSHES/TOOLS

Small angled brush

Small tapered brush

Flat rounded brush (optional)

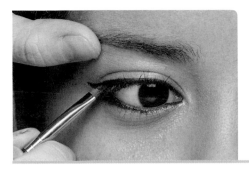

Using a small angled brush, apply black gel liner using the Cleopatra method (see page 23).

STEP ONE

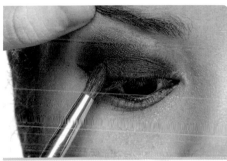

Using a small tapered brush, apply deep black eye shadow close to the lash line and blend upward. The black should lighten as it moves toward the crease and also toward the inner corners of the lids.

STEP TWO

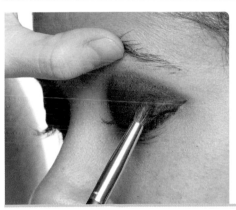

Wrap the black shadow around the outer corners of the eyes and onto the lower lash line. You might want to use the point of the small tapered brush or a flat rounded brush to do this, as it will give you more control over the shape you create with the shadow. The goal is to create a wing with shadow that connects from the lower lash line around to the upper outer lash line.

STEP THREE

CONTINUED

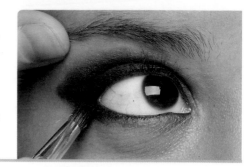

STEP FOUR Apply dark graphite eye shadow over the black shadow, applying generously in the crease, and wrapping around the outer corner of the upper lid and to the lower lid under the lash line. This will help keep the black shadow from fading and creasing.

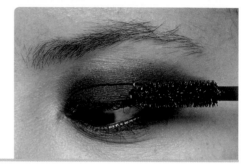

STEP FIVE Apply mascara.

STEP SIX Use your fingers to apply soft pink cream blush to the apples of the cheeks.

MOSS

A lot of women are wary of bold eye shadow colors. I get it. Golds, browns, and neutral tones are safe and flattering on everyone. But come on; live a little! Earth-tone greens are great choices if you're looking to spice it up but aren't ready for anything too shocking. If you choose a green with gold tones in it, the color will read more like a neutral, eliminating any fear of looking like you're auditioning for the Teenage Mutant Ninja Turtles.

MAKEUP

EYELINER Moss green pencil liner
Shown: Make Up For Ever Aqua Eyes Pencil in Green (#16L)

EYE SHADOW Iridescent brown-green eye shadow, deep gold-brown eye shadow, antique gold eye shadow
Shown: MAC Eye Shadow in Club, MAC Pigment in Old Gold, NARS Eye Shadow in Mekong

EYELASHES Black mascara
Shown: L'Oréal Carbon Black Voluminous Mascara

CHEEKS Gold- or warm-toned highlighter
Shown: Benefit Sun Beam Highlighter

LIPS Lip balm

BRUSHES/TOOLS

Tapered blending brush

Small tapered brush

Small flat rounded brush

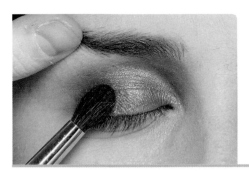

With a tapered blending brush, apply iridescent brown-green eye shadow to the lids from the lash line to the crease, blending into the crease so there are no hard lines. (I have never seen a shade like MAC Club made by any other company, so this one might be hard to match unless you go for the real thing.) **STEP ONE**

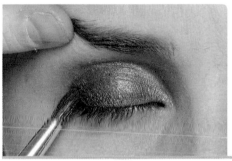

With a small tapered brush, apply deep gold-brown eye shadow close to the lash line as if it were a liner. **STEP TWO**

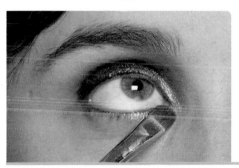

Using a small flat rounded brush, apply antique gold eye shadow to the inner corners of the top lids, wrapping around the inner corners of the eyes. **STEP THREE**

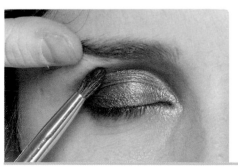

Using the small tapered brush, apply the deep gold-brown shadow into the crease, from the outer corner of the eyes all the way to the inner corner of the brows. **STEP FOUR**

CONTINUED

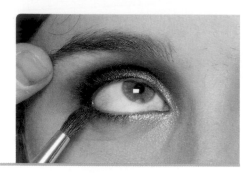

STEP FIVE Blend the same shadow into the outer corner of the lower lashes.

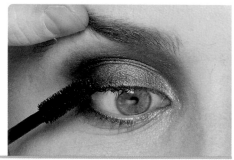

STEP SIX Apply mascara.

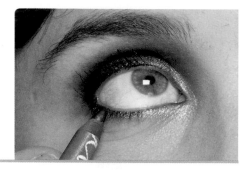

STEP SEVEN Apply moss green pencil liner to the lower lash line, over the shadow.

STEP EIGHT Tap and blend gold-toned highlighter onto the cheek-bones using your fingers.

pink DIAMONDS

I think of this as the perfect winter-date makeup. During cold months, your skin can become dull and colorless. To combat this, you can do a few things. One is to tell everyone that you've been on vacation and use bronzer to fake a tan. But lying is immoral, and falsifying vacation photos seems like a whole ordeal. The other is utilizing pink tones to help add warmth to your face. Pink cheeks and lips will help give the illusion that your winter skin is blushing. The pinks work with pale skin instead of fighting against it.

MAKEUP

EYELINER Black gel liner
Shown: MAC Fluidline in Blacktrack

EYE SHADOW Sparkly pink eye shadow, shimmery espresso-brown eye shadow
Shown: Make Up For Ever Aqua Cream in Pink Beige (#16), NARS Duo Eye Shadow in Cordura

EYELASHES Black mascara
Shown: L'Oréal Carbon Black Voluminous Mascara

CHEEKS Soft pink cream blush
Shown: Tarte Cheek Stain in True Love

LIPS Sheer pink lipstick
Shown: NARS Lipstick in Dolce Vita

BRUSHES/TOOLS

Small angled brush

Tapered blending brush (optional)

Small tapered brush

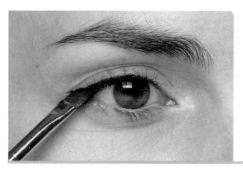

Using a small angled brush, apply black gel liner using the Natural Liner method (see page 21). Also line the top inner rim.

STEP ONE

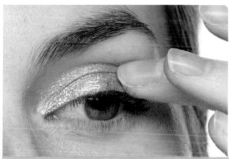

Apply sparkly pink eye shadow from the lash line to the crease and blend slightly above the crease onto the eye socket bone. If you are using a cream shadow, like me, apply it with your finger. If you're using powder shadow, apply with a tapered blending brush.

STEP TWO

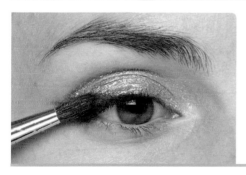

Using a small tapered brush, apply shimmery espresso-brown eye shadow along the lash line at the outer corners of the top lids and then, with the pointed end of the brush, create a wing with the eye shadow. Blend the edges of the shadow so they are soft.

STEP THREE

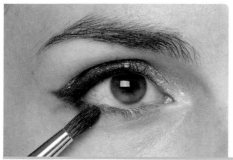

Apply the same espresso-brown shadow under the lower lash line, stopping just short of mid-eye.

STEP FOUR

CONTINUED

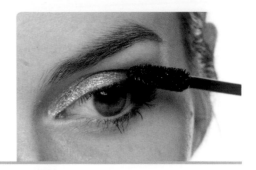

STEP FIVE Apply mascara.

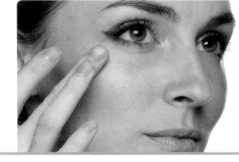

STEP SIX Apply soft pink cream blush to the apples of the cheeks with your finger, blending evenly into the skin.

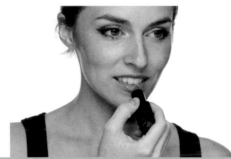

STEP SEVEN Apply sheer pink lipstick.

For the lips, go with light pink if you are fair skinned and a deeper pink if you have a darker complexion.

TIP

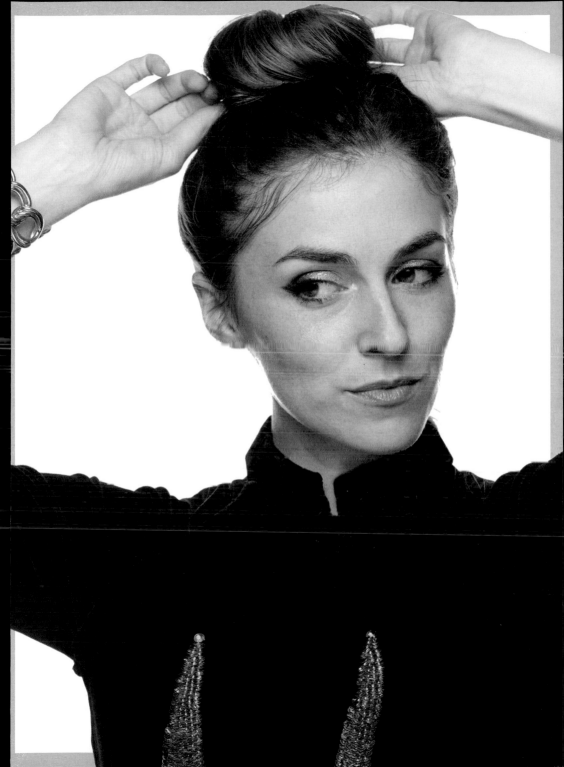

PARTY LOOKS

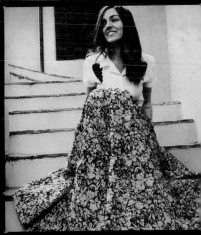

Turquoise and pink always remind me of Miami. Granted, as of yet, I have never actually been to Miami, so this observation is based entirely off my extensive viewing of The Golden Girls. Now, I don't think Sophia, Rose, Blanche, or Dorothy would be gallivanting about town in this makeup, but who knows really; there is an older woman who lives on my block who wears orange false eyelashes every day, so anything is possible. Either way, don't let that stop you from owning the night in this South Beach–inspired look.

MAKEUP

EYELINER Black gel liner, turquoise blue pencil liner
Shown: MAC Fluidline in Blacktrack, MAC Chromographic Pencil in Hi-Def Cyan

EYE SHADOW Electric turquoise eye shadow, iridescent ocean-blue eye shadow
Shown: MAC Eye Shadow in Electric Eel, NARS Duo Cream Eye Shadow in Burn It Blue

EYELASHES Black mascara
Shown: L'Oréal Carbon Black Voluminous Mascara

CHEEKS Gold- or warm-toned highlighter
Shown: Benefit Sun Beam Highlighter

LIPS Lip balm

BRUSHES/TOOLS

Small angled brush

Tapered blending brush

Small tapered brush

Small flat rounded brush

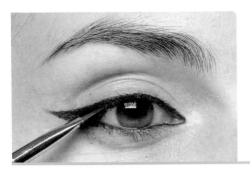

Apply black gel liner using the Cleopatra method (see page 23) with a small angled brush.

(see page 23)

STEP ONE

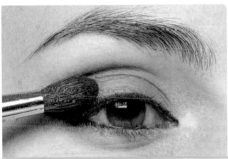

Use a tapered blending brush to apply electric turquoise eye shadow from the liner to the crease, blending thoroughly into the crease. Use the point of a small tapered brush to bring the turquoise shadow to the end of the liner wing.

STEP TWO

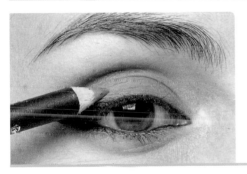

Apply turquoise blue pencil liner so it's on top of the black liner. You don't need to be super precise with this line because it will blend in with the shadow.

STEP THREE

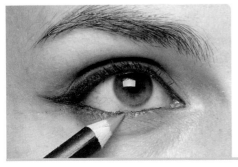

Use the pencil to line under the lower lash line. Extend the line all the way to the point of the black liner wing.

STEP FOUR

CONTINUED

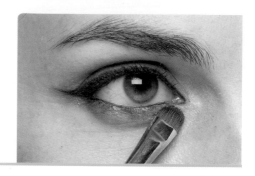

STEP FIVE — With a small flat rounded brush, apply iridescent ocean-blue eye shadow to the lower lash line.

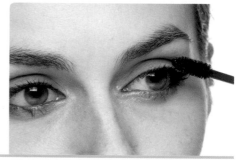

STEP SIX — Apply mascara.

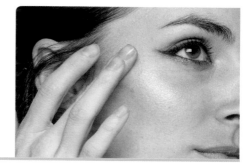

STEP SEVEN — Using your fingers, apply gold-toned highlighter to the cheekbones and blend well.

Red Light

Red eyeliner: It might sound extreme, but, if done correctly, red liner can be one of the coolest looks in your repertoire. That said, if done incorrectly, it looks like you're suffering from allergies—let's try to avoid that! With red liner, it's all about how you apply it and where you wear it. I always apply black liner first, then use red liner above it. If you apply red directly to your lash line, you run the risk of appearing sickly. And trust me, unless you are a waifish model from the early '90s, that's not your best look.

You probably want to save this look for a party, when avant-garde makeup is appropriate, and won't want to wear it to your corporate desk job. (After all, you don't want your coworkers to know how interesting you are. Then they'll want to hang out with you!) This is a bold look with both red eyes and red lips. Why not take it a step further and wear it with something red?

MAKEUP

EYELINER Black gel liner, red liquid liner, bronze pencil liner
Shown: MAC Fluidline in Blacktrack, Make Up For Ever Aqua Liner in Iridescent Red (#10), Make Up For Ever Aqua Eyes Pencil in Bronze (#10L)

EYE SHADOW None

EYELASHES Black mascara
Shown: L'Oréal Carbon Black Voluminous Mascara

CHEEKS Shimmery white highlighter
Shown: MAC Cream Colour Base in Luna

LIPS Orange-red lipstick
Shown: NARS Semi Matte Lipstick in Heat Wave

BRUSHES/TOOLS Small angled brush

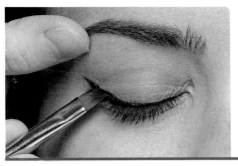

With a small angled brush, apply black gel liner using the '60s Wing method (see page 22). Also apply liner to the upper inner rims, and lightly to the outer corner of the lower inner rims.

STEP ONE

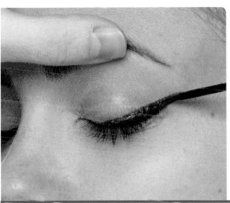

Apply red liquid liner above the black liner on the upper lid, along the outer half of the lid. Be sure to start with a very thin line in the center of the lid so it looks like the red is originating out of the black liner. You don't want a hard blob of red sitting on top of the black in the center of your lid. Your red liner will get thicker as it moves out along the eye, eventually meeting the black liner at the wing point.

STEP TWO

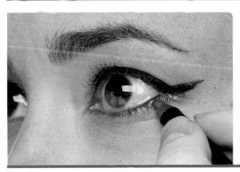

Apply bronze pencil liner to the outer corners of the lower lash line and into the lashes.

STEP THREE

CONTINUED

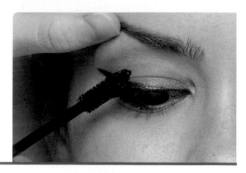

STEP FOUR Apply mascara.

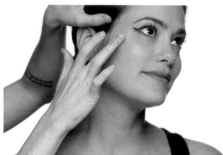

STEP FIVE Apply shimmery white highlighter to the tops of the cheekbones using your finger and blend well into your skin.

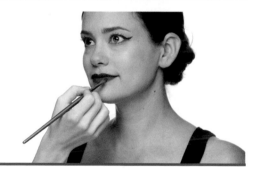

STEP SIX Apply orange-red lipstick.

TIP

Red lipstick can have either orange or blue undertones. Reds with orange undertones are more casual and bright, while blue undertones give your lipstick a more dramatic and moody feel. I used a red with orange undertones here.

the
STARLET

This look is inspired by the glamour of 1940s starlets such as Veronica Lake and Rita Hayworth. In their films, these women exemplified beauty: their makeup was perfect, and not a single hair was out of place. Because movies were shot in black-and-white, makeup artists used all sorts of weird makeup colors to achieve the desired shades of gray to appear on film. It wasn't uncommon for actresses to wear black lipstick, which gave the illusion on film that they had dark red lips. I don't want you to look like you just came from an Insane Clown Posse concert, though, so I've created this look in full color. Wear with your fanciest dress to channel the sophistication of these iconic beauties.

MAKEUP

EYELINER Black gel liner
Shown: MAC Fluidline in Blacktrack

EYE SHADOW Light taupe cream shadow
Shown: Benefit Creaseless Cream Shadow in Birthday Suit

EYELASHES Black mascara
Shown: L'Oréal Carbon Black Voluminous Mascara

CHEEKS Bare

LIPS Deep wine lip pencil, burgundy lipstick
Shown: MAC Lip Pencil in Vino, MAC Lipmix in Burgundy

BRUSHES/TOOLS

Small angled brush

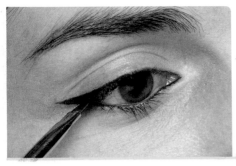

Using a small angled brush, apply black gel liner using the Natural Liner method (see page 21), also lining the inner rims of the upper and lower lids.

STEP ONE

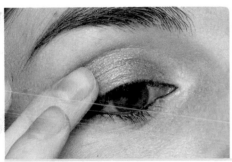

Use your finger to apply light taupe cream shadow to the top lids from the liner to the crease, and blend into the crease.

STEP TWO

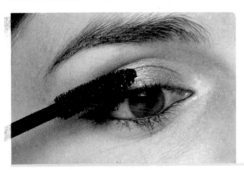

Apply mascara.

STEP THREE

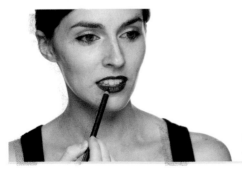

Fill in your lips with deep wine lip pencil.

STEP FOUR

CONTINUED

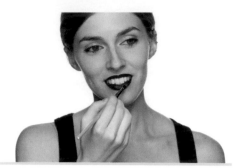

STEP FIVE Apply burgundy lipstick on top of the pencil.

As with other strong lip looks, I recommend going over the edges of your lipstick with a liner so the edges are crisp.

TIP

TWIGGY

If I could be transported to a different time and place it would be to London during the swinging '60s—no question. To step into Twiggy's shoes for a day would be my ultimate dream come true. Unfortunately, we are a long way from time machines, so I'll have to settle with simply re-creating the look that made '60s London so iconic (while listening to the Rolling Stones on my record player, of course!). Naturally, this look should be worn with your best mod minidress and go-go boots.

MAKEUP

EYELINER Black liquid liner, slate pencil liner, white pencil liner
Shown: The Body Shop Liquid Liner in Black, Tarte Skinny SmolderEyes Liner in Slate, MAC Eye Kohl in Fascinating

EYE SHADOW Light beige matte eye shadow
Shown: Bobbi Brown Eye Shadow in Bone

EYELASHES Black mascara, individual false lashes
Shown: L'Oréal Carbon Black Voluminous Mascara

CHEEKS Matte rose-beige or brown-beige blush
Shown: MAC Powder Blush in Harmony

LIPS Lip balm, matte nude or neutral lip pencil or lipstick
Shown: MAC Lip Pencil in Have to Have It

BRUSHES/TOOLS

Small angled brush

Smudge sponge

Pointed liner brush

Tweezers

Lash glue

Blush brush

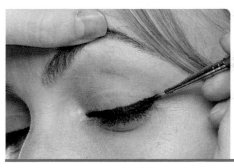

With a small angled brush, apply black liquid liner in a dramatic '60s Wing (see page 22). This liner will be covered by eye shadow, but you'll reapply it once the shadow is applied. **STEP ONE**

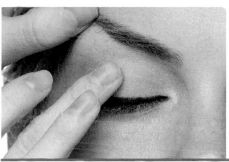

Using your finger, apply light beige matte eye shadow to the top lid from the liner to the crease. Press the shadow into your lid so it is very pigmented. **STEP TWO**

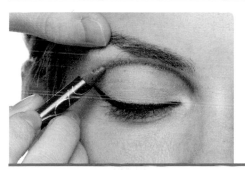

Using slate pencil liner, draw a line just above the eye socket bone from the inner corner to the point of the liner wing. This line goes above the eye socket bone so that it is visible when your eyes are open. Once the line is in place, go over it with a smudge sponge to soften the edges. **STEP THREE**

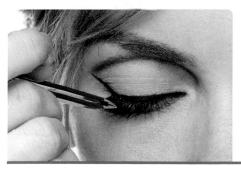

Apply individual false lashes to the upper lashes (see page 28). Once dry, apply a few generous coats of mascara. **STEP FOUR**

CONTINUED

Using a pointed liner brush, apply dots of black liquid liner to the lower lash line. Be sure to leave some space between the dots. (In the '60s, women would actually draw fake lashes on, but I decided to do dots instead, which makes the makeup look more modern and less costumey.)

STEP FIVE

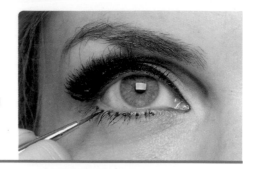

STEP SIX

With white pencil liner, make dots in between the black dots.

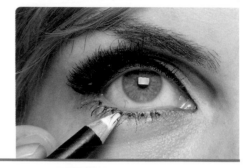

STEP SEVEN

Using a blush brush, apply matte rose-beige blush to the cheekbones.

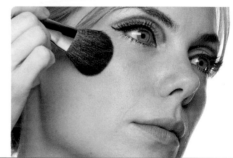

STEP EIGHT

Apply some lip balm and fill in the lips with matte nude lip pencil.

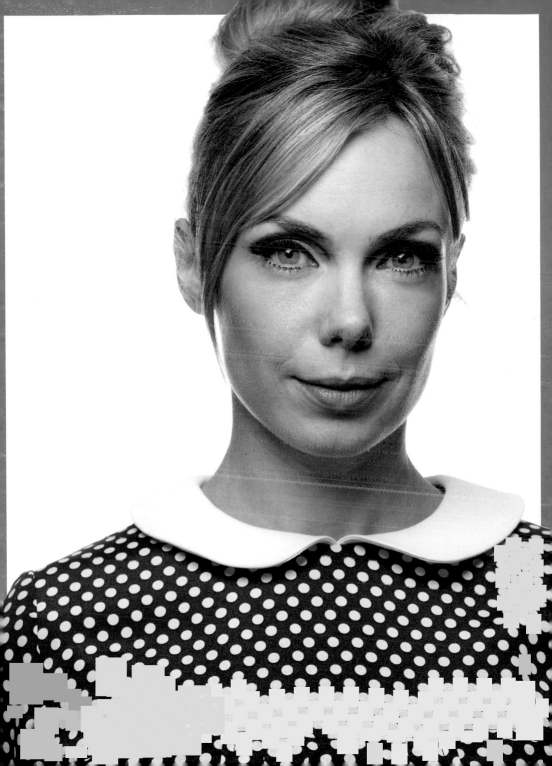

Purple Haze

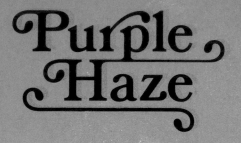

My obsession with the past doesn't stop at London mod. No, as a young girl, I also fancied myself a flower child of the late '60s/early '70s. I wore long broom skirts and Indian patterned shirts my parents saved for me. You're probably wondering if I was popular with my peers. I was not!

Though hippies didn't traditionally wear much, if any, makeup, they would draw flowers and peace signs on their faces. I don't advise doing that unless it's Halloween, because, let's be honest, you want people to talk to you without rolling their eyes. Instead, try this look inspired by peace, love, and frolicking in wildflowers at dusk. It's light on the eyeliner, which is good news for those of you who are sick of practicing your wings.

MAKEUP

EYELINER Black gel liner
Shown: MAC Fluidline in Blacktrack

EYE SHADOW Deep purple cream shadow, shimmery eggplant eye shadow, light amethyst eye shadow
Shown: Smashbox Limitless 15 Hour Wear Cream Shadow in Iris, NARS Duo Eye Shadow in Eurydice, Benefit Longwear Powder Shadow in Raincheck

EYELASHES Black mascara
Shown: L'Oréal Carbon Black Voluminous Mascara

CHEEKS Bare

LIPS Lip balm

BRUSHES/TOOLS

Small angled brush

Tapered blending brush

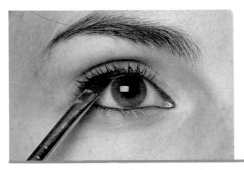

Using a small angled brush, apply black gel liner to the inner rims of the upper and lower lids. **STEP ONE**

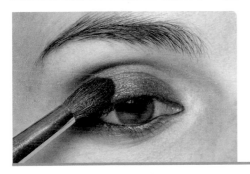

Using your finger, apply deep purple cream shadow to the lids, keeping it close to the lash line. Apply under the lower lash line as well. **STEP TWO**

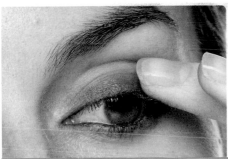

Using a tapered blending brush, apply shimmery eggplant eye shadow all over the lid, blending onto the eye socket bone. **STEP THREE**

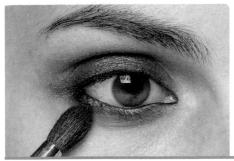

Continue applying this color, wrapping around the outer corner of the eye and into the lower lash line below the purple cream shadow you previously applied. **STEP FOUR**

CONTINUED

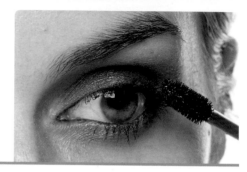

STEP FIVE Using the tapered blending brush, apply light amethyst eye shadow around the edges of the eggplant shadow around the upper and lower lid.

STEP SIX Apply mascara.

This makeup should appear like a spectrum of purple. The darkest purple will be closest to the lashes and will fade to lighter purple as it moves away from the eyes.

TIP

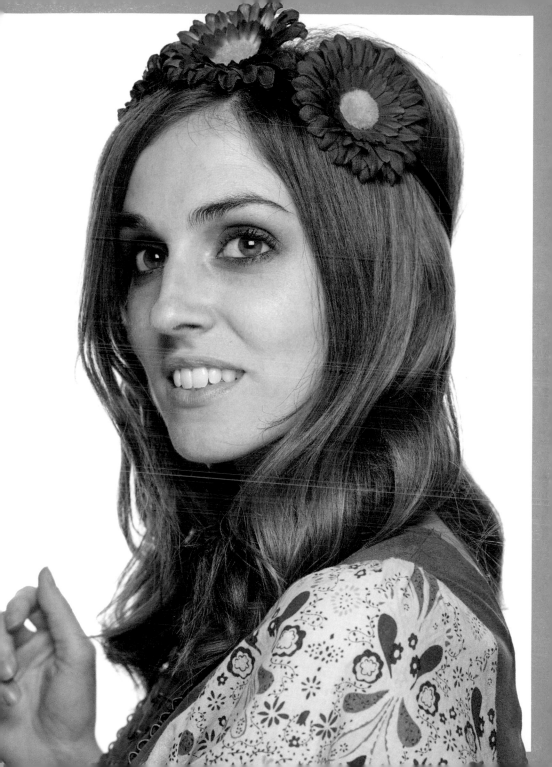

GOLDEN EYE

Have you ever wondered what it would feel like to line your eyes with actual gold? No? Yeah, me either—it's probably very heavy and expensive. Luckily, there are some very nice yellow liners out there, such as this one from Make Up For Ever, that add a slight sparkly highlight that, when paired with bronze liner, make your lids look like they are wearing a queen's crown. This is a fun, striking look if you don't feel like dealing with eye shadow but still want to draw attention to your eyes.

MAKEUP

EYELINER Black gel liner, metallic brown or bronze pencil liner, sparkly gold liquid liner
Shown: MAC Fluidline in Blacktrack, Tarte Skinny SmolderEYES in Sunstone Bronze, Make Up For Ever Aqua Liner in Diamond Gold (#1)

EYE SHADOW None

EYELASHES Black mascara
Shown: L'Oréal Carbon Black Voluminous Mascara

CHEEKS Gold- or warm-toned highlighter
Shown: Benefit Sun Beam Highlighter

LIPS Lip balm, deep wine lip pencil or lipstick, clear lip gloss
Shown: MAC Lip Pencil in Vino, MAC LipGlass in Clear

BRUSHES/TOOLS

Small angled brush

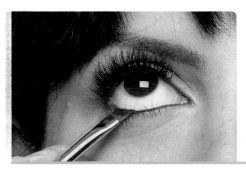

Using a small angled brush, apply black gel liner to the upper and lower inner rims from the inner to outer corners.

STEP ONE

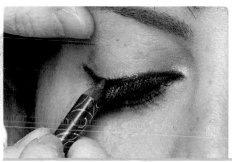

Apply metallic brown pencil liner using the '60s Wing method (see page 22).

STEP TWO

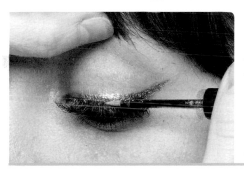

Apply sparkly gold liquid liner over the bronze liner you just applied. You might want to extend the wing here to make it even more dramatic. Liquid liner will come with a brush already in it; use this to apply.

STEP THREE

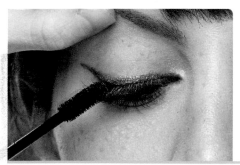

Apply mascara.

STEP FOUR

CONTINUED

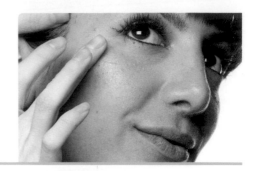

STEP FIVE Using your finger, apply gold-toned highlighter to the cheekbones.

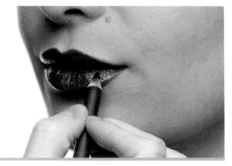

STEP SIX Apply lip balm and fill the lips with deep wine lip pencil.

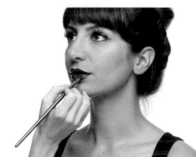

STEP SEVEN Go over your lips with clear lip gloss.

If you have wine lipstick, feel free to use that instead of the pencil. The type of product isn't what's important here; it's the color.

TIP

AFTER MID-NIGHT

This is the ultimate rock-and-roll eye, worthy of guitar smashing and hotel room trashing. Inspired by the female rockers of the early '80s, this look says, "I've been up for two days, and I look awesome." I went for a slightly cleaner look with the eye, but if you want a more "messy rocker" feel, don't worry about your shadow being too polished and precisely placed; in fact, you can try applying everything with just your finger. Perfect for the darkest bars and the loudest concerts, wear this one with a T-shirt and a tight pair of leather pants.

MAKEUP

EYELINER Black gel liner, pearl highlighter, metallic bronze pencil liner
Shown: MAC Fluidline in Blacktrack, NARS Soft Touch Shadow Pencil in Hollywoodland, Make Up For Ever Aqua Eyes Pencil in Bronze (#10L)

EYE SHADOW Shimmery taupe cream shadow, deep taupe eye shadow, dark mocha eye shadow with gold shimmer
Shown: Make Up For Ever Aqua Cream in Taupe (#15), MAC Eye Shadow in Satin Taupe, NARS Eye Shadow in Mekong

EYELASHES Black mascara
Shown: L'Oréal Carbon Black Voluminous Mascara

CHEEKS Matte rose-beige blush
Shown: MAC Powder Blush in Harmony

LIPS Lip balm

BRUSHES/TOOLS

Small angled brush

Tapered blending brush

Small tapered brush

Small flat rounded brush

Blush brush

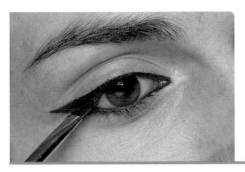

Using a small angled brush, line the eyes with black gel liner using the Cleopatra method (see page 23). **STEP ONE**

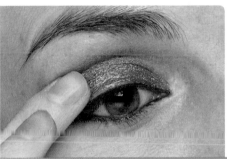

Using your finger, apply shimmery taupe cream shadow to the lids from the lash line, blending slightly above the crease. **STEP TWO**

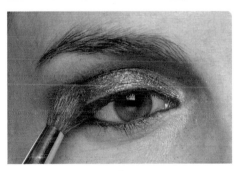

With a tapered blending brush, apply deep taupe eye shadow to the crease. Blend the shadow all the way in toward the inner corner of the eye and up toward the inner corner of the brow. The area between the inner corner of the eye and the inner corner of the brow should be shadowed, but there should be no shadow on the outer portion of the brow bone, directly under the brow. If there is you might be like, "Hey, I kind of resemble a streetwalker," which is generally not a good look. Always keep dark shadow off your brow bone! **STEP THREE**

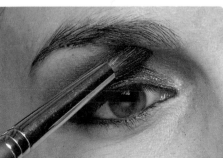

CONTINUED

STEP FOUR

Apply pearl highlighter onto the brow bone, following along the arch of your brow. Blend lightly with your finger to get rid of any visible pencil marks.

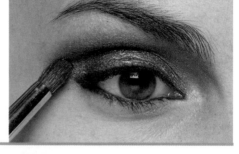

STEP FIVE

With a small tapered brush, apply dark mocha eye shadow to the outer corner of the eyes in a wing and into the crease. Follow the natural shape of the eye socket bone and crease to determine where the wing should be; depending on the size of your eye, your wing might be bigger or smaller than mine.

STEP SIX

Using a small flat rounded brush, dust the same dark mocha shadow lightly below the lower lash line. This will create a drop shadow that you can make either small or very dramatic depending on what kind of a look you want. (I went for dramatic.) This look uses a lot of shadow, and you've probably covered your liner, so take this time to go over your eyeliner if you'd like to make it bolder.

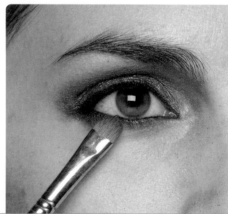

CONTINUED

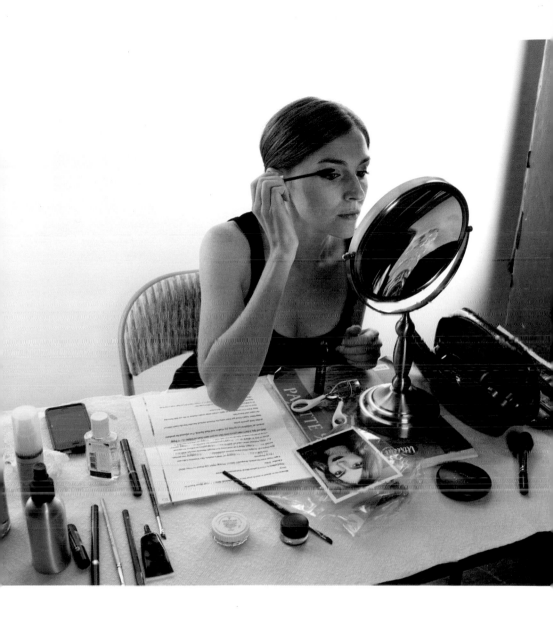

STEP SEVEN Apply metallic bronze pencil liner around the inner corners of the eyes, following the natural shape of the eyes.

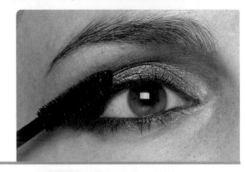

STEP EIGHT Apply mascara.

Using a blush brush, sweep matte rose-beige blush onto the hollow of the cheekbone (the area right under the bone). This will create a more defined cheekbone area—a good trick if you don't have naturally pro-

STEP NINE nounced cheekbones!

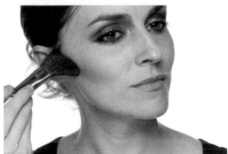

COSTUME LOOKS

SNOW LEOPARD

Need a cool Halloween costume, but don't have a ton of time to put one together? Welcome to my world every year on October 30! The snow leopard is your solution—it's one of the best looks and easiest costumes I have in my repertoire. This makeup is surprisingly easy to apply because it uses techniques (such as a smoky eye) that you've been learning about through this whole book and products (black gel liner) that you should already have in your makeup bag. Plus, real leopard spots are never perfect, so you don't need to be too precise with your own spots. Pair this look with cat ears and an all-black outfit and you're ready for that party you were supposed to be at an hour ago.

MAKEUP

FACE Shimmery white cream face makeup, opaque white face paint, opaque black face paint
Shown: Make Up For Ever Aqua Cream in Snow (#4), Ben Nye Creme Color in White and Black

EYELINER Black gel liner
Shown: MAC Fluidline in Blacktrack

EYE SHADOW Dark graphite eye shadow
Shown: NARS Duo Eye Shadow in Eurydice

BROWS Black gel liner
Shown: MAC Fluidline in Blacktrack

EYELASHES Black mascara
Shown: L'Oréal Carbon Black Voluminous Mascara

LIPS Lip balm, deep wine lip pencil
Shown: MAC Lip Pencil in Vino

BRUSHES/TOOLS

Sponge applicator

Small angled brush

Tapered blending brush

Small flat rounded brush

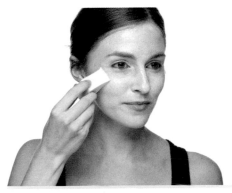

Mix shimmery white cream face makeup with a smaller amount of opaque white face paint. (You can blend cream products on palette paper, which can be found at any art supply store.) Using a sponge applicator, apply the mixture so it covers your face and blends evenly onto your neck. Your application doesn't need to be super-opaque.

STEP ONE

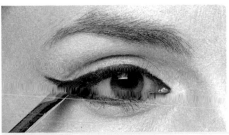

Using a small angled brush, apply black gel liner using the Cleopatra method (see page 23). Since this is a costume, you'll want to make your liner thicker than normal, with an even more dramatic wing.

STEP TWO

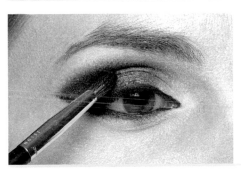

Using a tapered blending brush, apply dark graphite eye shadow to the lid and in the crease, just as you would if you were creating a smoky eye (see page 92). Again, make the eye more dramatic than you would with your everyday makeup.

STEP THREE

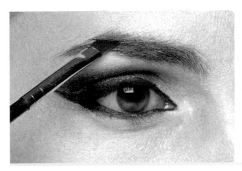

With the small angled brush that you used for your liner, brush black gel liner lightly into your eyebrows, filling them in. Apply mascara.

STEP FOUR

CONTINUED

*Test a few spots on the inside of your forearm before applying them to your face. Also try image searching leopard spots to get a better idea of their shape. Did you know Google image search was designed specifically for people to research leopard spots for Halloween makeup?**

**Claim not adequately researched.*

TIP

STEP FIVE

Using opaque black face paint and a small flat rounded brush, apply leopard spots to the forehead, temples, and cheekbones. Apply as many or as few spots as you like.

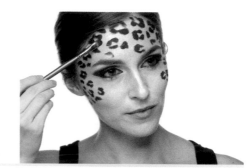

STEP SIX

Use the small flat rounded brush to fill in the underside of the nose with black face paint. Bring the black down slightly below your nose into a point.

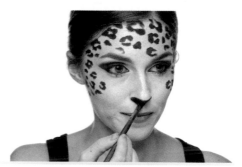

STEP SEVEN

Apply a bit of lip balm, then fill in the lips with deep wine lip pencil.

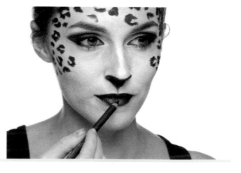

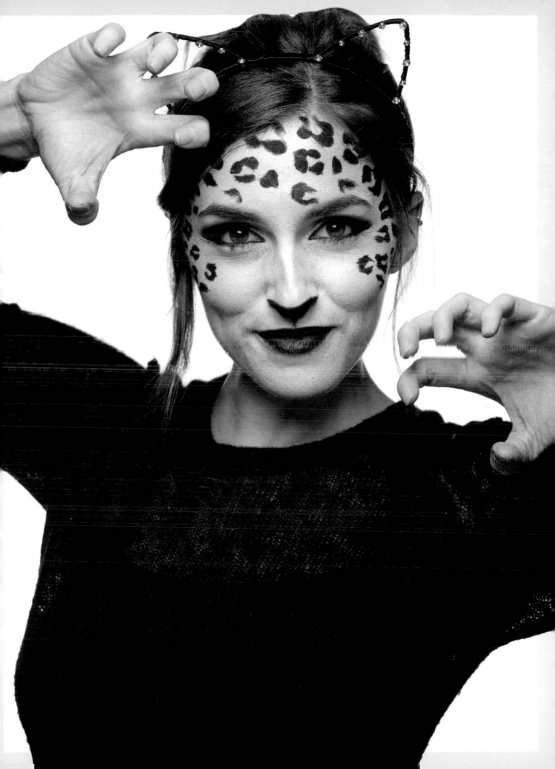

Peacock

Peacock feathers have always conjured an image of glamour and decadence in my mind. They are very Gatsby-esque, which is exactly why I've designed this makeup look with some 1920s flair. With this makeup, I recommend putting on your best dress and most opulent costume jewelry, and throwing yourself an all-night party. (You can find peacock feathers at almost any craft store.)

MAKEUP

FACE Gold cream face makeup
Shown: Make Up For Ever Aqua Cream in Gold (#11)

EYELINER Black gel liner
Shown: MAC Fluidline in Blacktrack

EYE SHADOW Shimmery white cream shadow, teal cream shadow
Shown: Make Up For Ever Aqua Cream in Snow (#4), Smashbox Limitless 15 Hour Wear Cream Shadow in Neptune

BROWS Electric blue pencil liner
Shown: Make Up For Ever Aqua Eyes Pencil in Blue with Green Highlights (#12L)

EYELASHES Black mascara
Shown: L'Oréal Carbon Black Voluminous Mascara

LIPS Deep wine lip pencil or lipstick, clear lip gloss
Shown: MAC Lip Pencil in Vino, MAC LipGlass in Clear

BRUSHES/TOOLS

Sponge applicator

Small angled brush

Small flat rounded brush

Lash glue

Peacock feathers

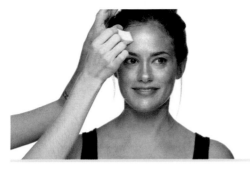

Using a sponge applicator, apply a thin layer of gold cream face makeup all over your face. **STEP ONE**

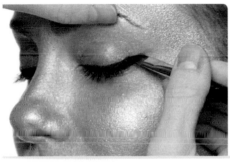

Using a small angled brush, apply black gel liner using the Cleopatra method (see page 23). **STEP TWO**

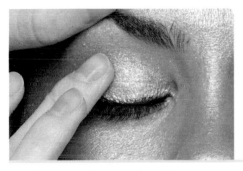

Using your finger, apply shimmery white cream shadow to the lids from the liner up to the crease, blending into the crease. **STEP THREE**

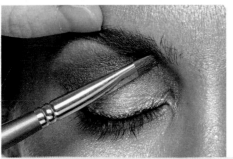

With a small flat rounded brush, apply teal cream shadow above the white shadow from the point of the liner wings, along the crease, and all the way to the inner corners of the brows. Concentrate the darkest-pigmented area around the outer portion of the eyes, so the teal gets lighter as it moves in toward the brows. **STEP FOUR**

CONTINUED

STEP FIVE With electric blue pencil liner, make short strokes from the top of the brows, moving upward to create the illusion of feathers. Blend the electric blue into the actual brows as well.

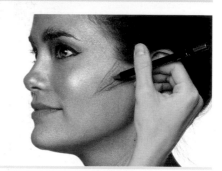

STEP SIX Using the same pencil, make a couple of lines just under the cheekbones; these will be covered by feathers, so don't worry about how they look. They are just a guide so your feathers end up symmetrical on each side of the face.

STEP SEVEN Fill in the lips with deep wine lip pencil and go over it with a shiny clear gloss. Apply mascara.

STEP EIGHT Apply a few dots of lash glue onto the shaft of a peacock feather and place it where you drew lines in Step Six. Hold it in place for a minute until the lash glue dries. Apply two more feathers on each side, moving up the side of the face. Take time to make sure your feathers are symmetrical.

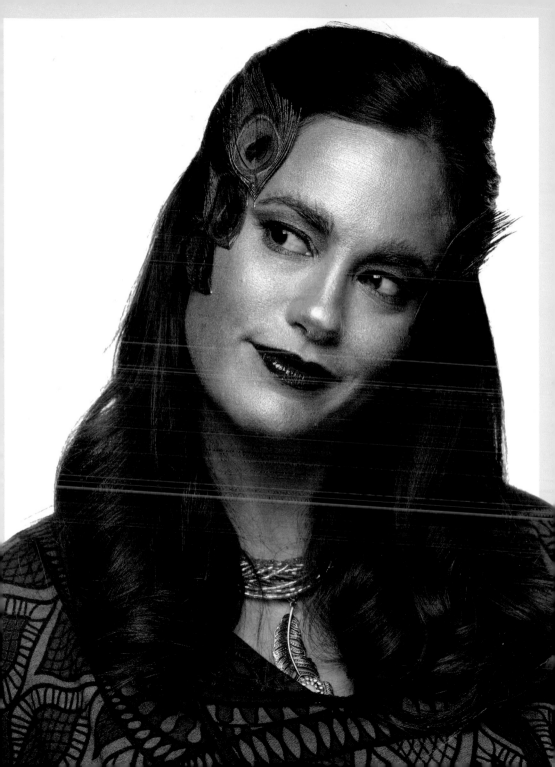

CRACKED
CHINA
DOLL

✳ ✳ ✳ ✳ ✳

There are Halloweens when I want to look a little creepy, and others when I want to look elegant and feminine. But wait—what if I want to combine these attributes into one perfect costume? I give you the Cracked China Doll. It's elegant! It's creepy! It's my favorite combination of things!

I would suggest pairing this makeup with a black-and-white ensemble. For extra creepiness, wear a black baby doll dress with a Peter Pan (rounded) collar. With this costume your face will still look nice, while evoking the ghoulishness this holiday was founded on. Let us not forget, Halloween was originally a time when people dressed up as something that terrified them. I dare you to name one person who isn't even a little afraid of an old cracked doll.

MAKEUP

FACE Light foundation, opaque white face paint, powder, dark brown eye shadow, black gel liner
Shown: Make Up For Ever HD Foundation in Marble (# 117), Ben Nye Creme Color in White, MAC Blot Powder in Light, Bobbi Brown Eye Shadow in Mahogany, MAC Fluidline in Blacktrack

EYELINER Black liquid liner
Shown: MAC Liquidlast Liner

EYE SHADOW Beige eye shadow, slate eye shadow, deep plum eye shadow
Shown: Bobbi Brown Eye Shadow in Bone, Bobbi Brown Eye Shadow in Slate, MAC Eye Shadow in Blackberry

BROWS Black gel liner
Shown: MAC Fluidline in Blacktrack